dave cooper's

bent

FANTAGRAPHICS BOOKS INC

dave cooper's

bent

FANTAGRAPHICS BOOKS INC

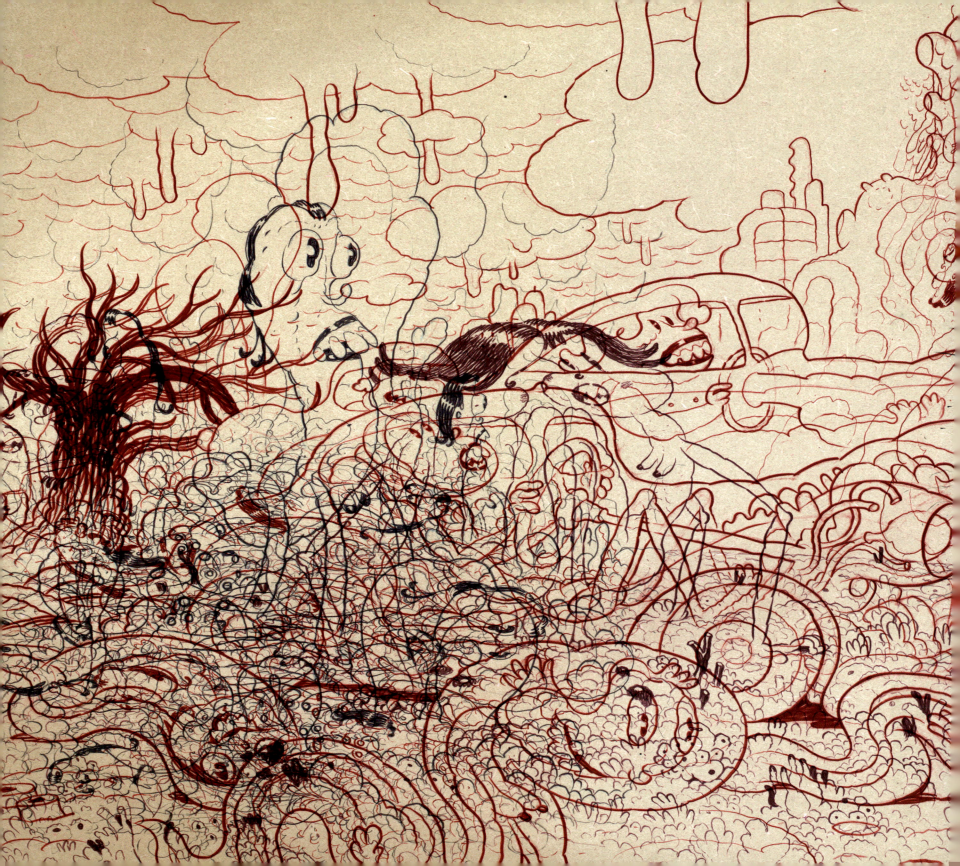

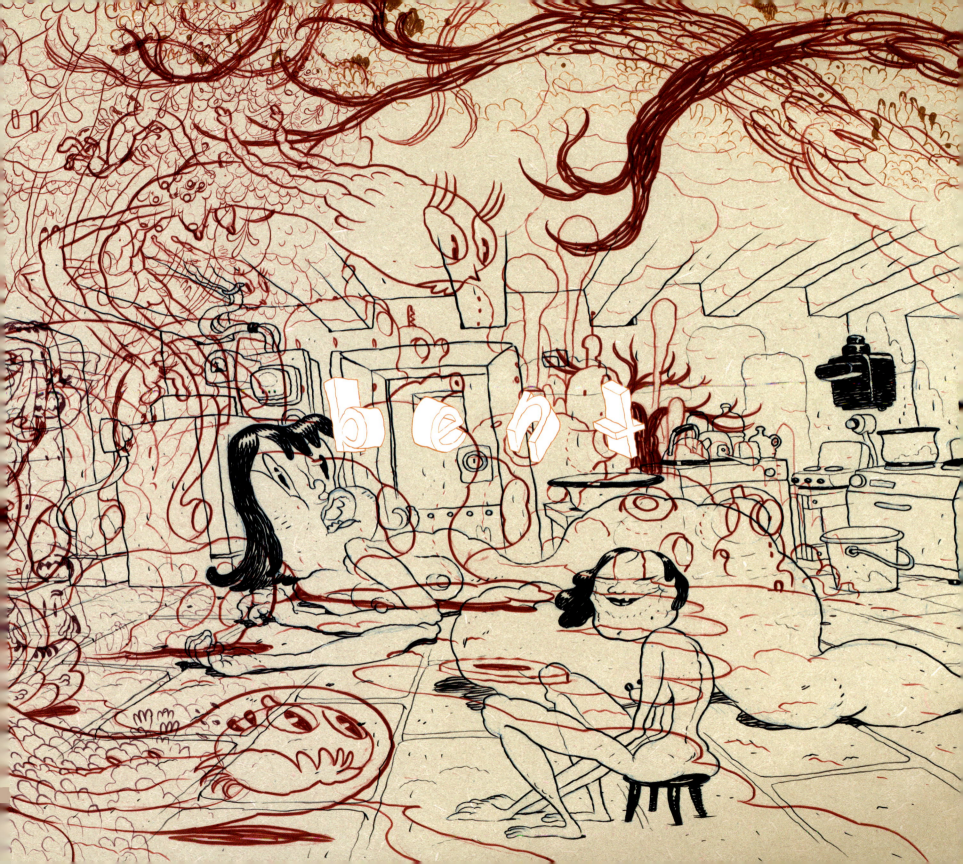

with love to my beautiful wife, Julie

and for my Dad, may he rest in peace

this book collects an assortment of
work produced between November, 2004
and May, 2010 — for a variety of gallery
shows, private collectors, and publications

Bent and Free

The salient feature of all the artists I truly admire is one: compulsion — the feeling that whatever images pour out of them, ooze from a place that pulsates with unholy need.

Over the years, both as a filmmaker and an art lover, I believe I have developed a sixth sense that allows me to recognize the overexcited pulse of the true outsiders.

Early on in their careers (think early Lynch or pre-*Cahiers* Hitchcock or Joe Coleman or Ryden amongst others) their trademark becomes evident — much like the M.O. of a criminal offender — but their hunger seldom wanes: You are always certain that they get off on their own stuff.

They just can't help it. They are users. They get high on their own supply…

Which brings me to Dave Cooper: a true reprobate of the brush. Early in his career he emerged as a full-fledged fetishist, enraptured by cellulite and overbites, but these sexual partialisms have metastasized and mutated into something bigger and more powerful.

I am utterly convinced that, in the past, Dave Cooper mixed his oils with night sweat, and teeth grindings, the guilt monkey on his back riding him mercilessly, forcing him to stack his paintings like sandbags against the flood.

He was St Anthony or Ulysses, tied to the mast with an aching boner and rope burns from the struggle. Lust was a cosmic joke God played against all of us funny, awkward creatures. His art had the same confessional urgency as a lipstick message scribbled in a crime scene: "Stop me before I kill again"

But now — now the images have evolved into visions of a savage paradise, depicting serene Utopias of libertine abandon and sexual cannibalism.

These new landscapes remain unprecedented and hypnotic. At play here are both the innocence and wholesomeness of childhood plastic toys and the sweaty, adult realities of desire.

Polymorphic nymphs tempt or acquiesce to each other as they transform, pupate and ooze onto each other, fusing their bodies, contorting them in a never-ending search for pleasure. Their flesh is morbid, pale — even translucent — and decidedly abnormal for our world. But there they are in their dioramas of abandon: weightless, listless — floating like humanoid anemones at the bottom of the sea.

Whatever imprinting occurred in this man's sexual awakening, these paintings are the Rosetta Stone to decipher it. So much for Canadians being placid, nice fellas.

But beyond any prurient content, these new paintings represent a perfect artistic balance between message and medium. Dave's paintings are technically irreproachable and meticulously planned. His compositions and use of color hand-deliver the purpose and direction of each piece, finding harmony or jarring contrast, and conspiring to disturb and arouse both the artist and the audience.

The prodigious use of form and rendering allow Cooper to populate his landscapes with exactly the creatures and environments he needs. His profuse, elaborate, zealous rendering of each flower, each cloud, each polyp — like a vinyl William Holman Hunt — transmogrifying them all past the point of artificiality. The landscape is there to frame — uncaring and remote or, alternatively, to sensually smother the characters, nurturing their play.

It is here where Cooper's reverie has decidedly taken a step forward from his previous work. In BENT, the artist has moved past the disturbing trend of objectifying the pillowy nymphs and seems at peace inhabiting them too. He has become part of the picture.

And there Dave Cooper is — under many disguises — unhindered by ego and giddy with lust. Swinging. Ulysses has surrendered. He is bent.

Bent and free…

Guillermo del Toro
New Zealand, 2010.

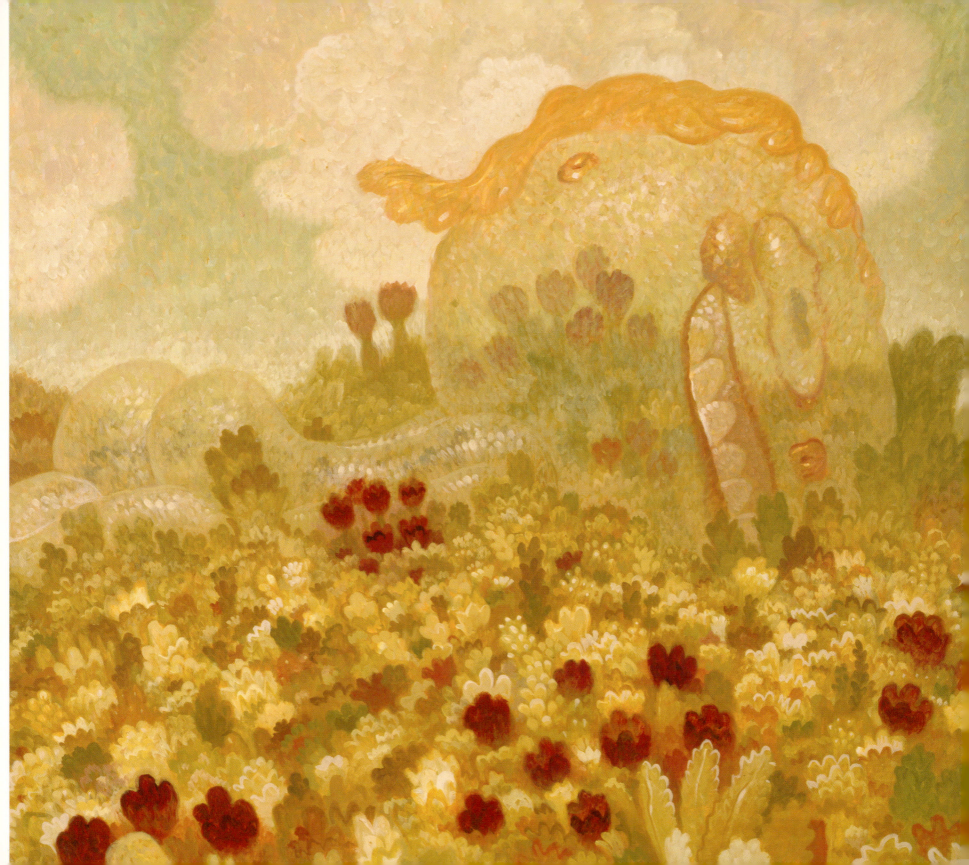

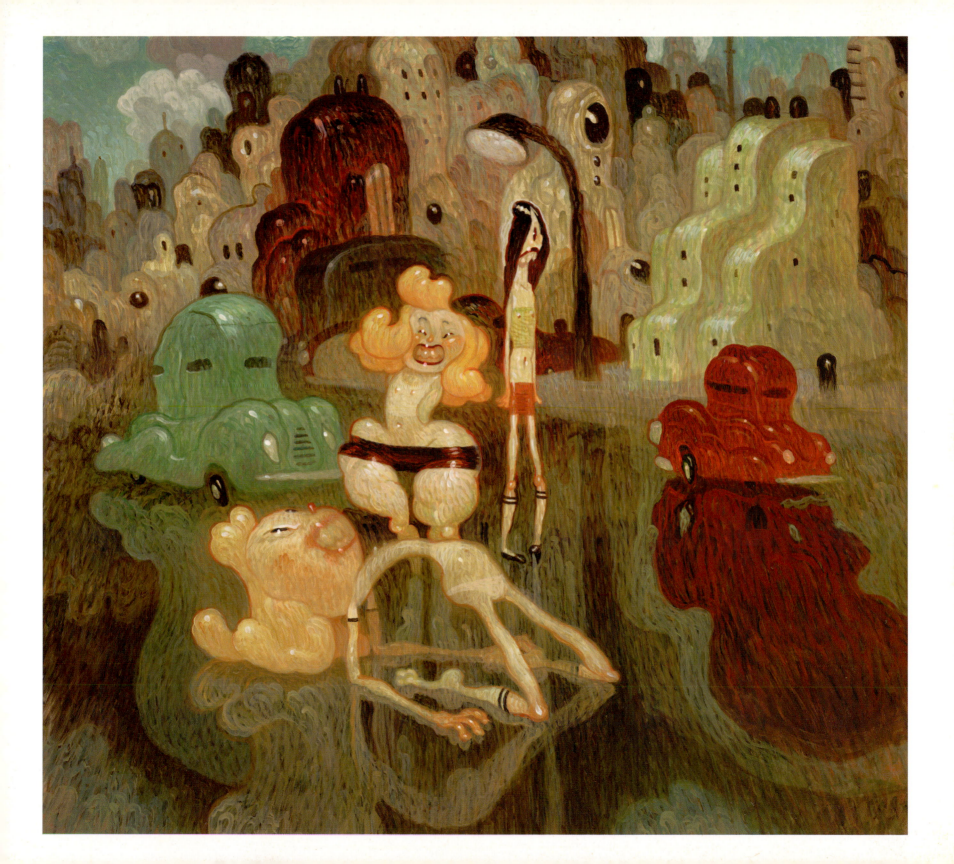

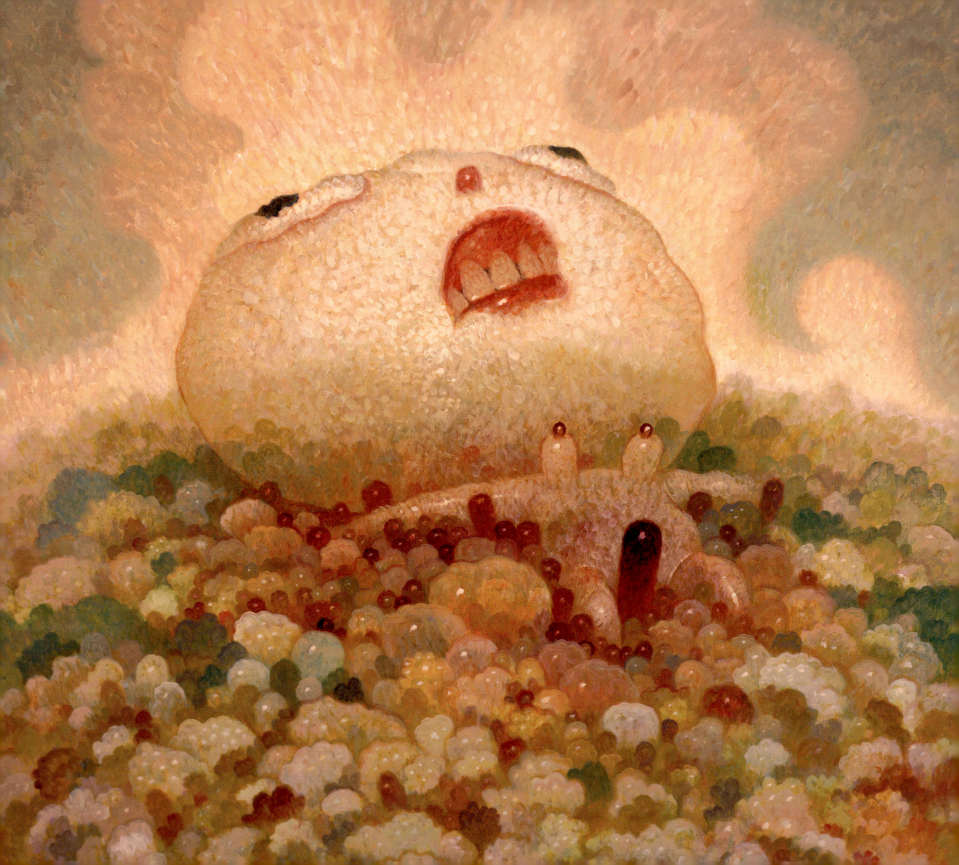

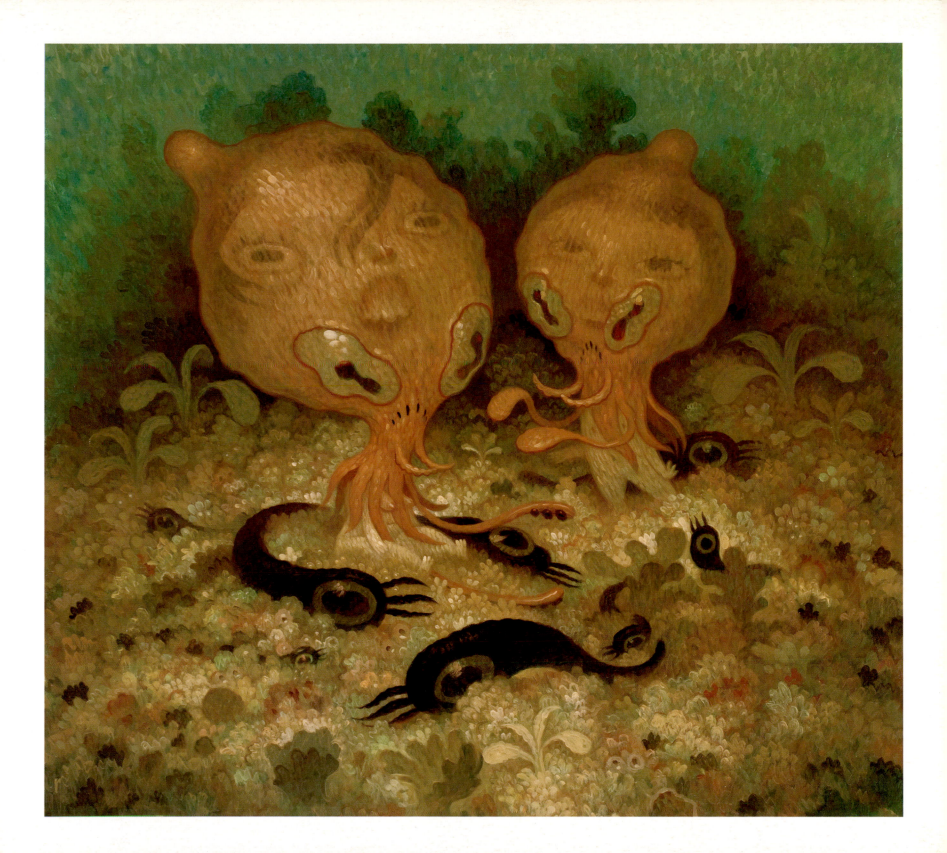

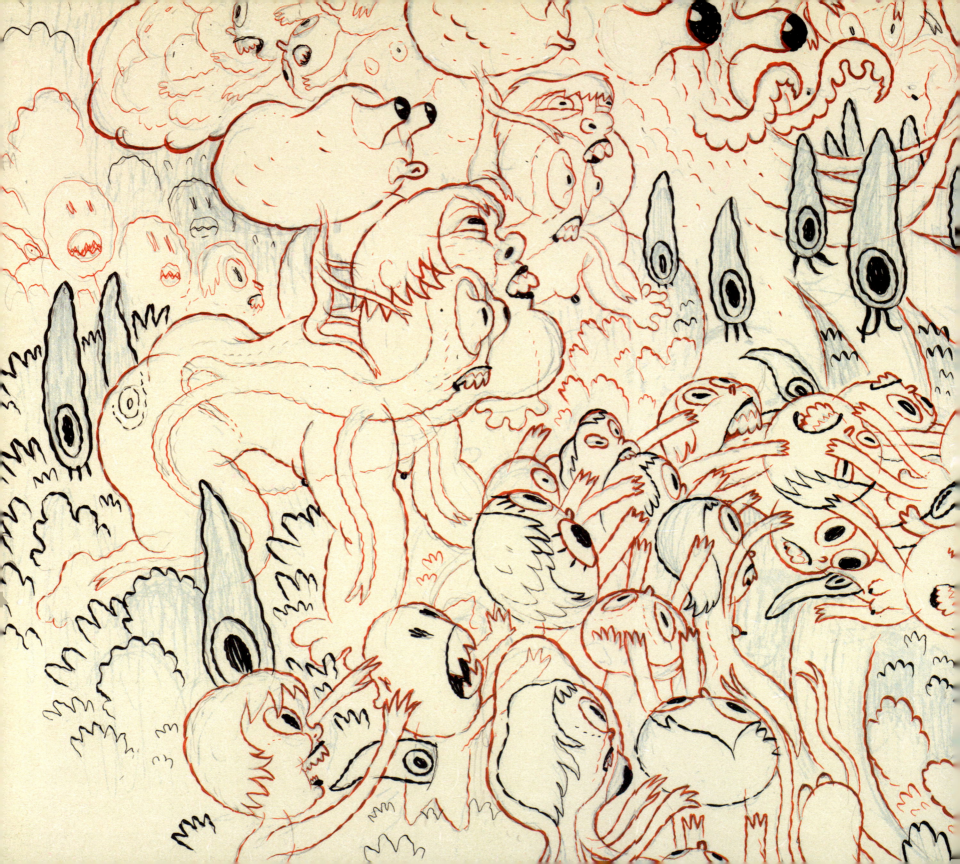

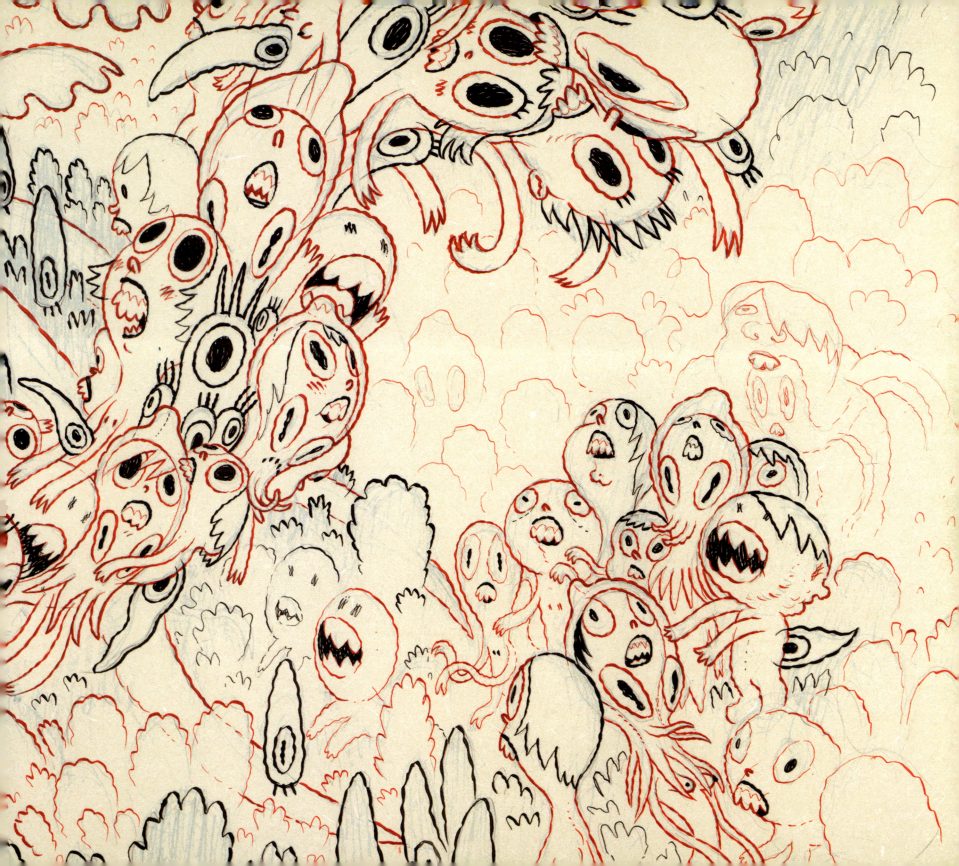

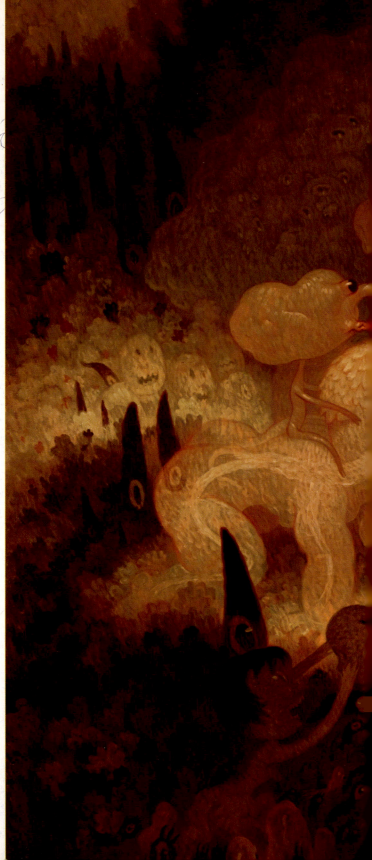

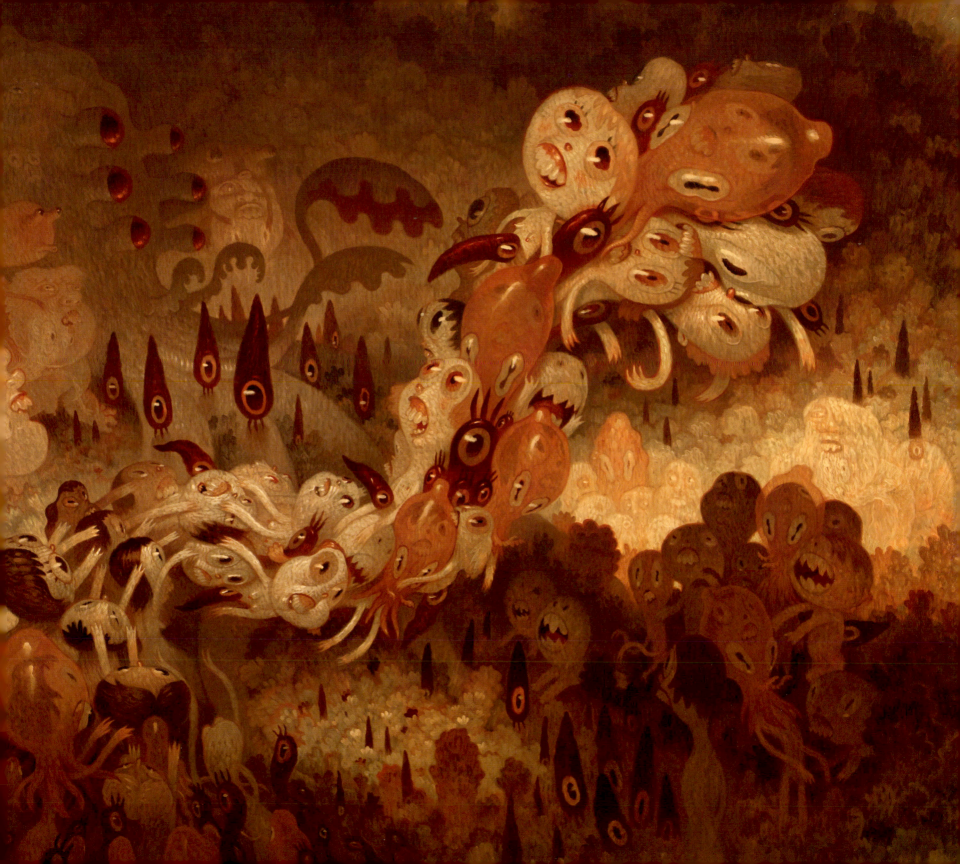

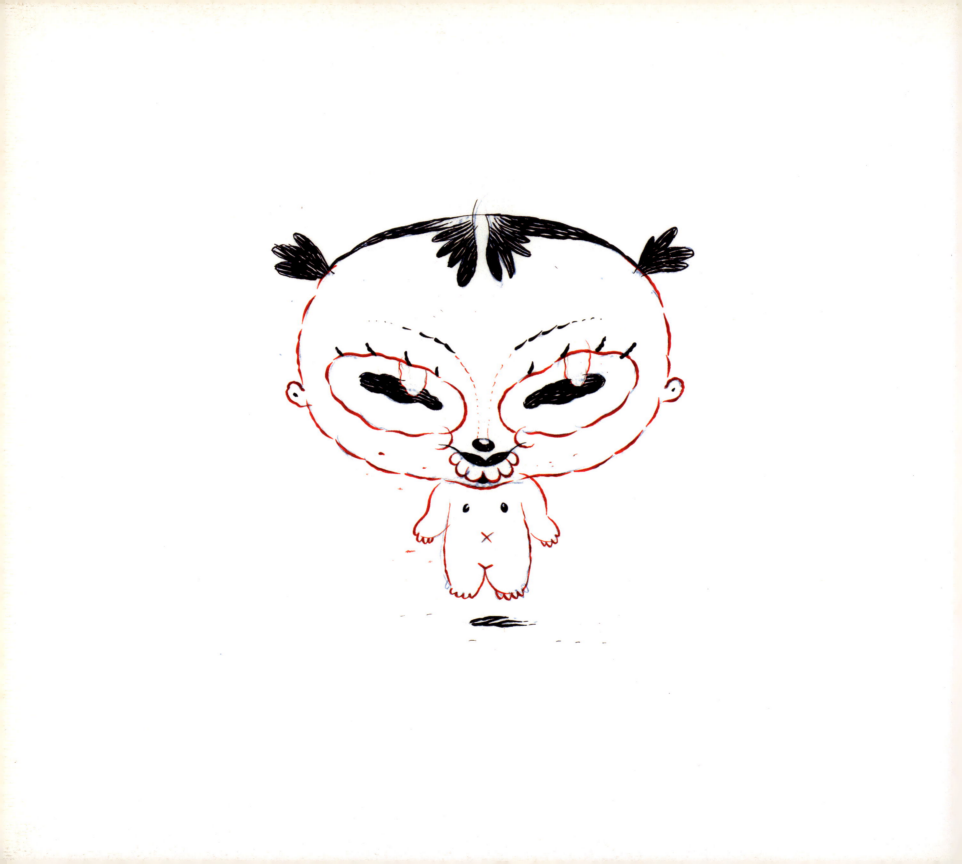

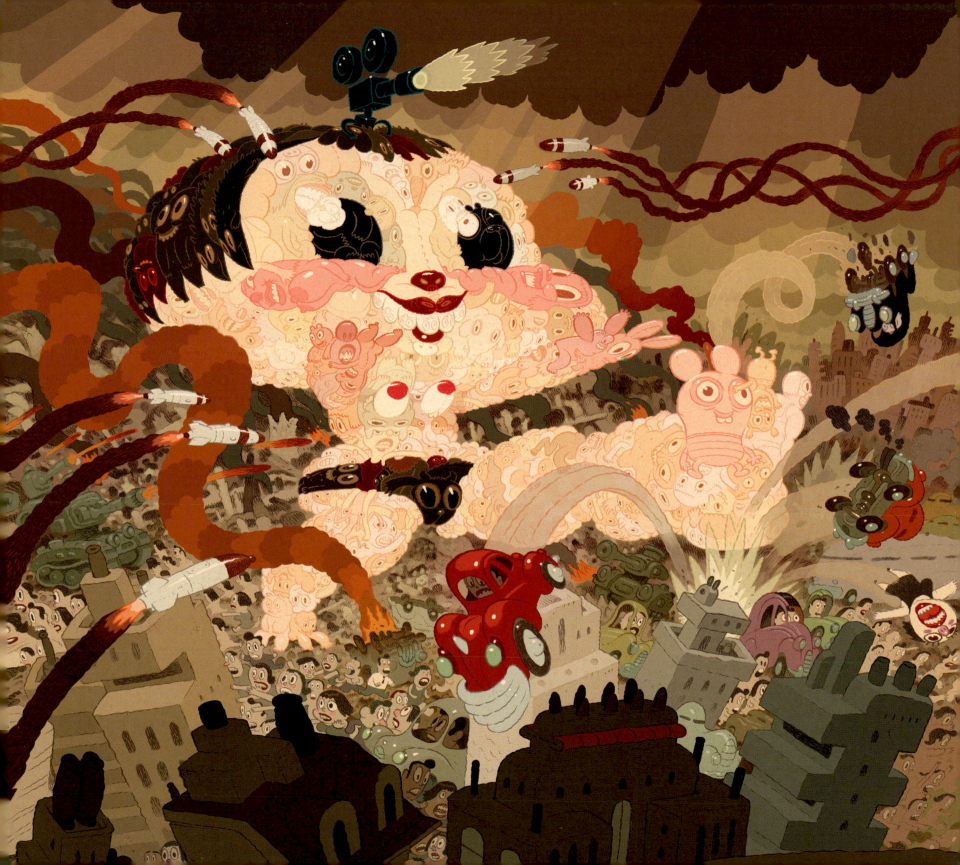

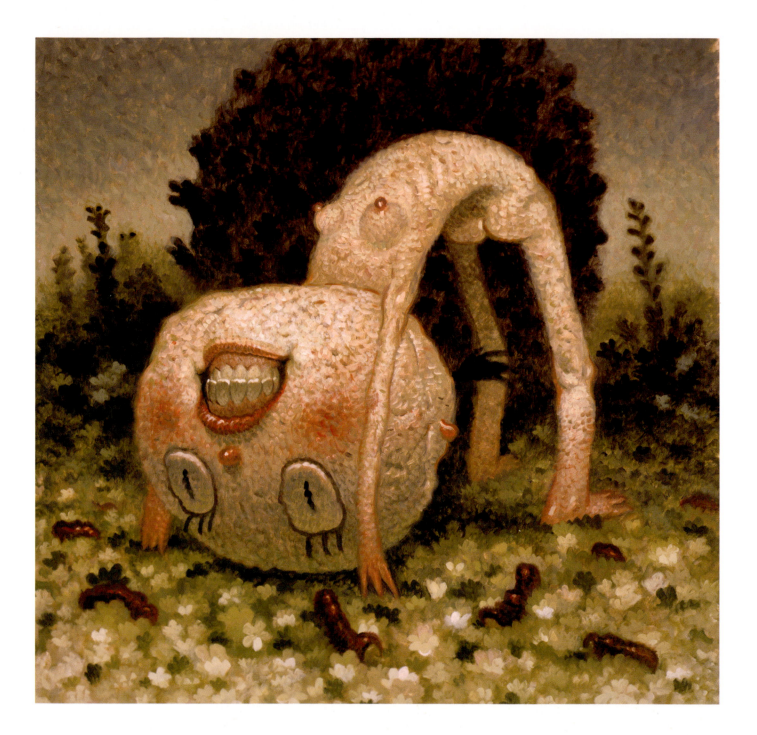

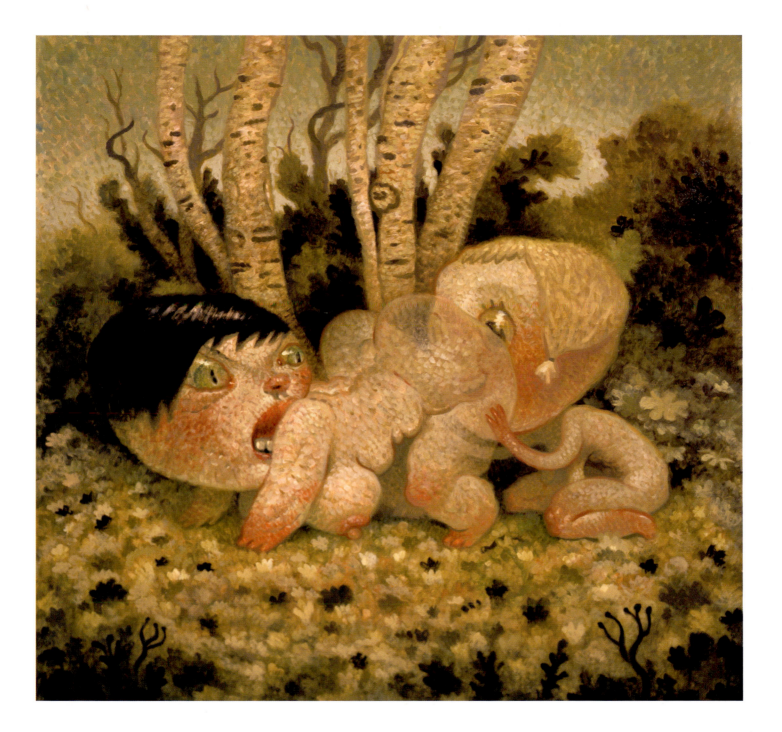

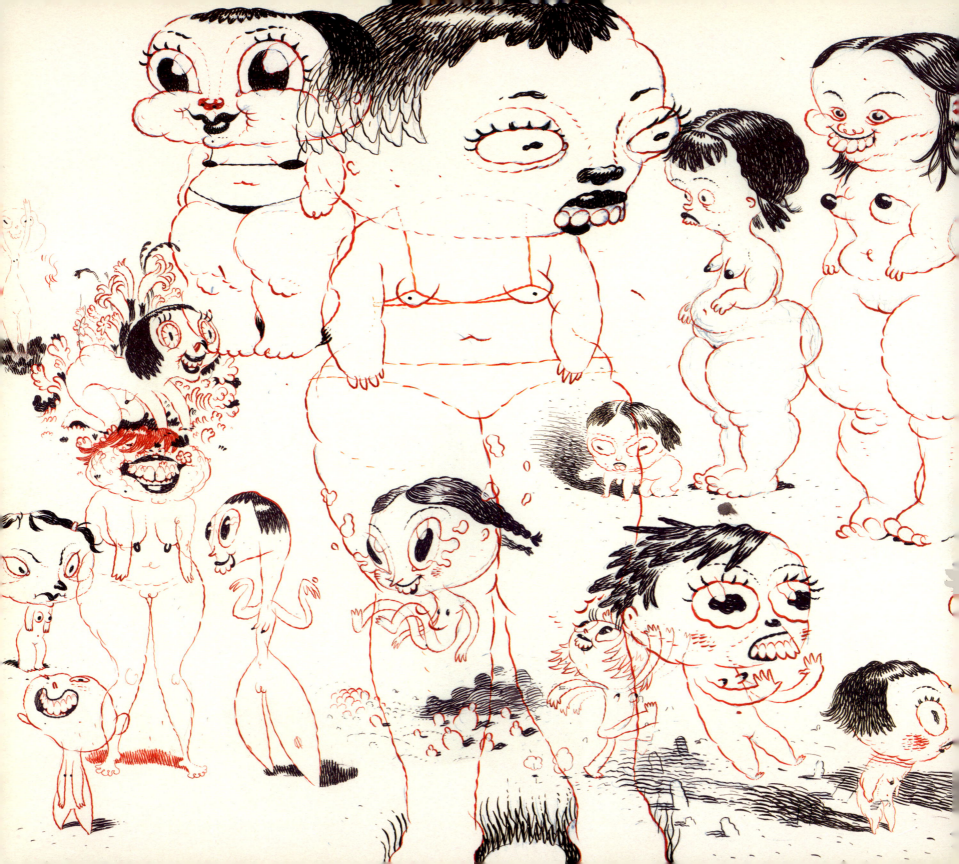

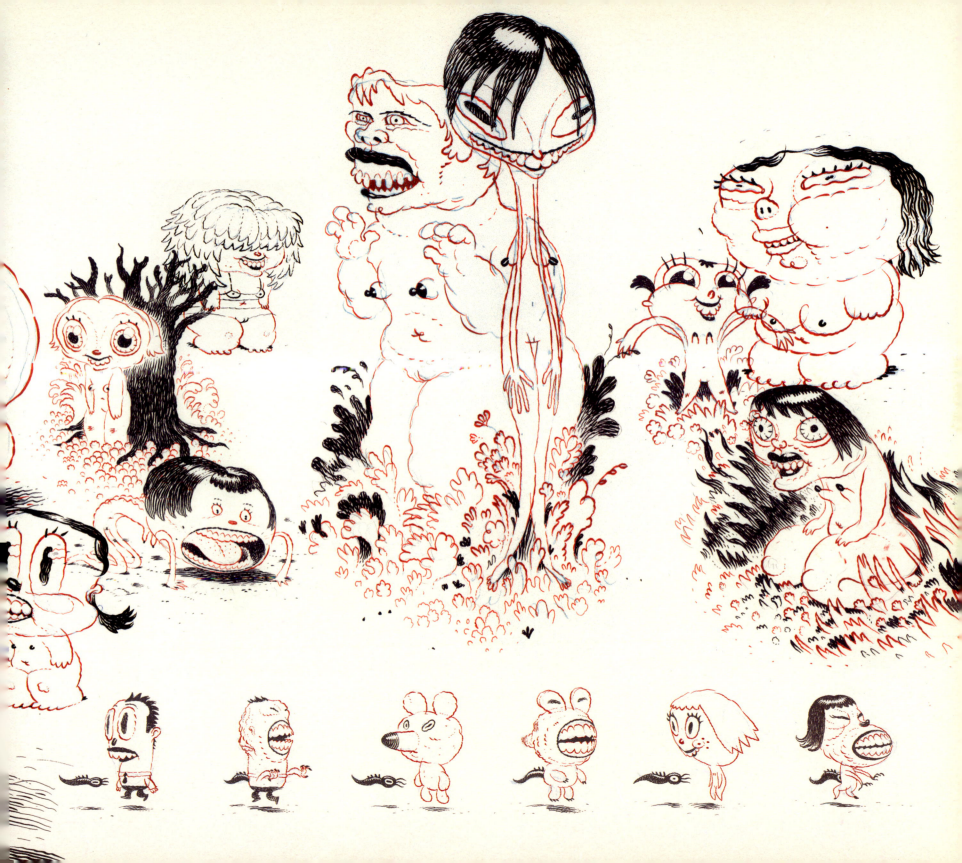

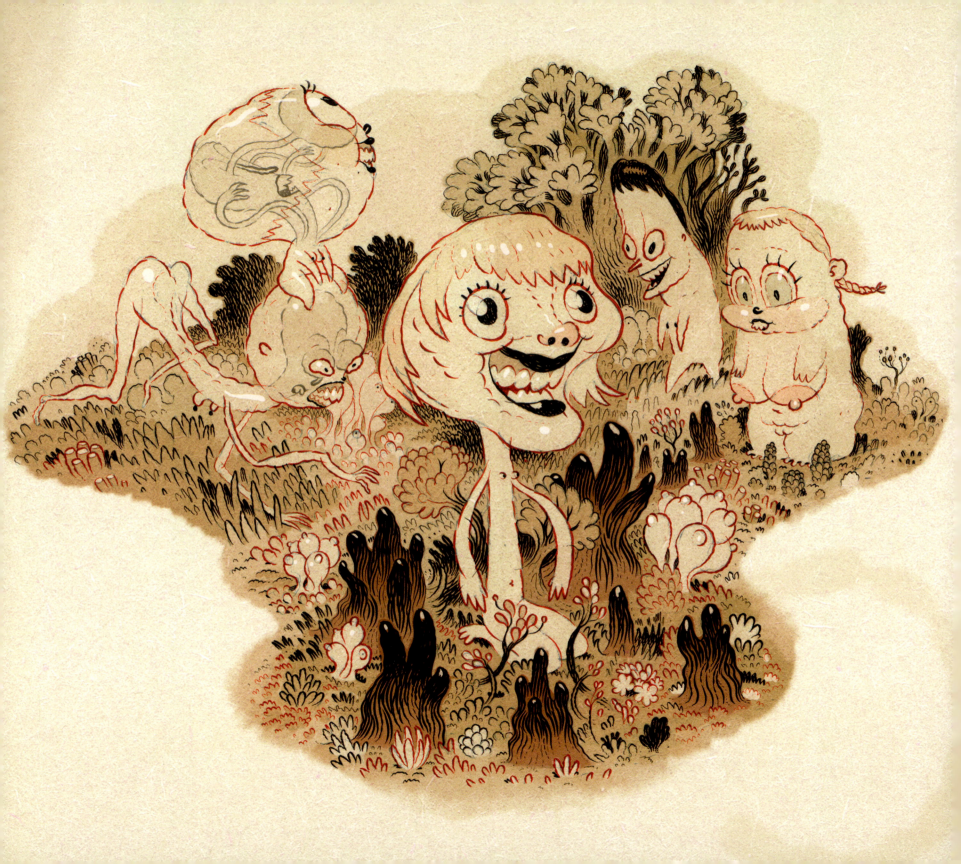

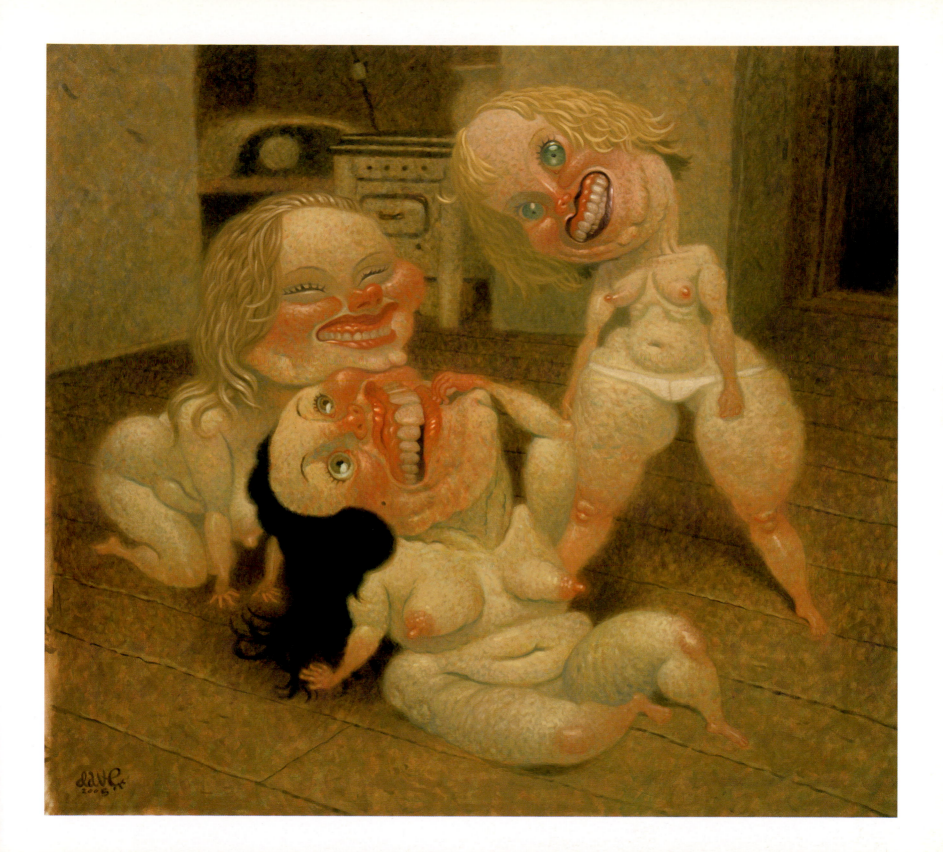

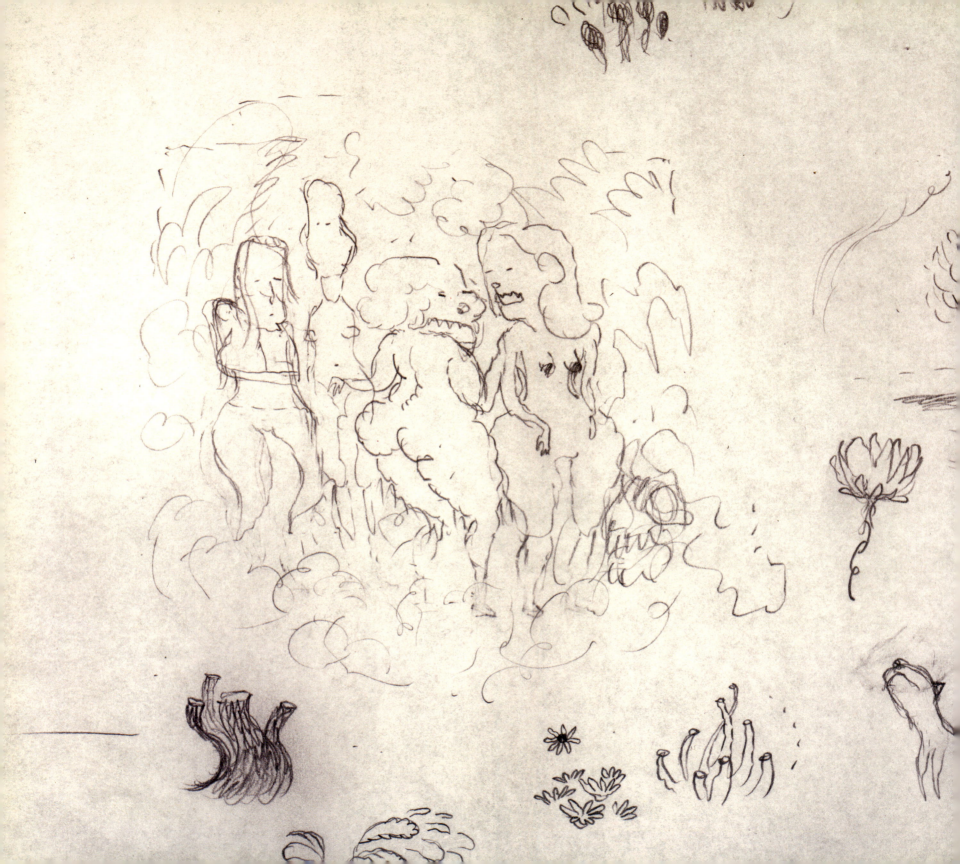

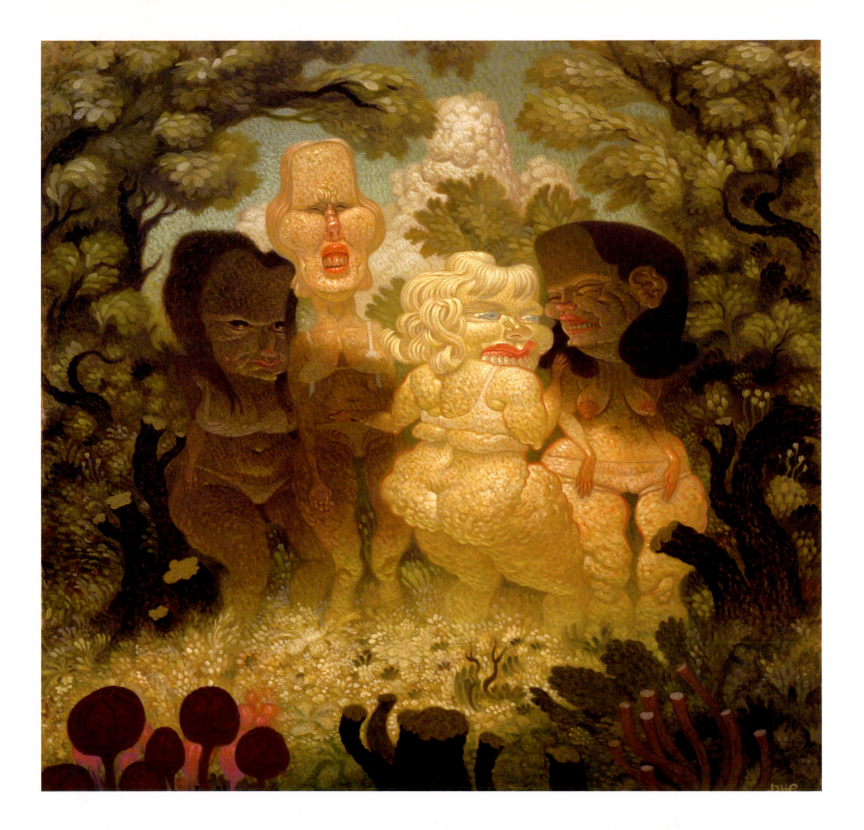

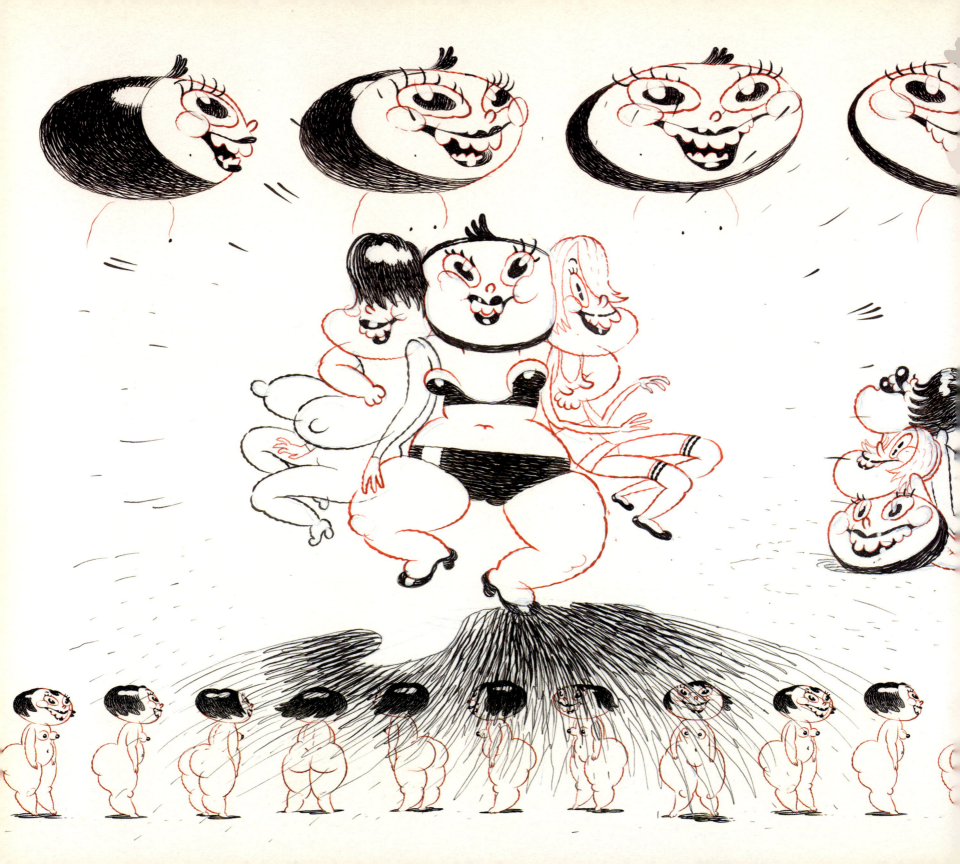

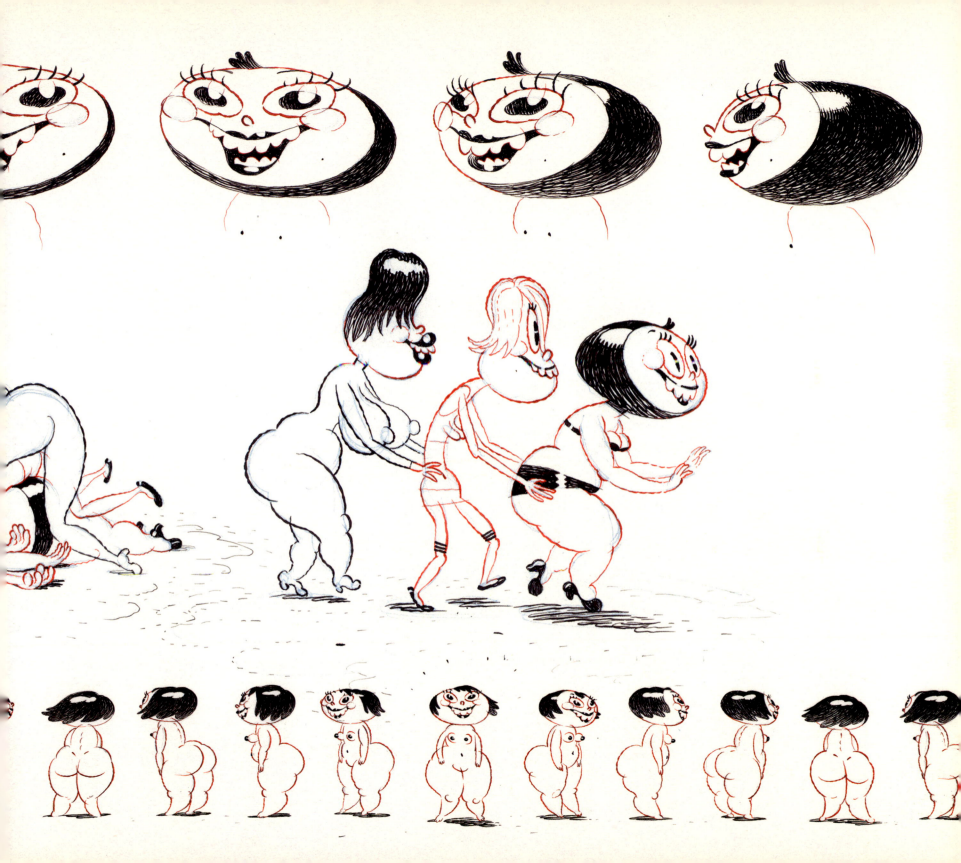

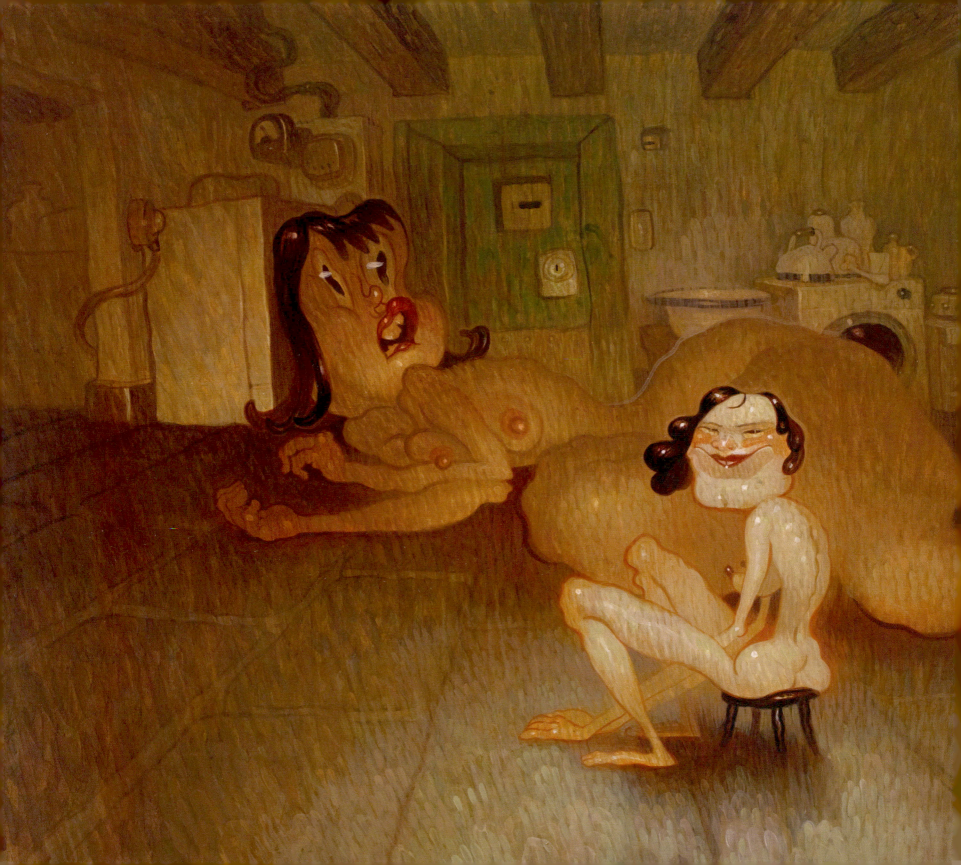

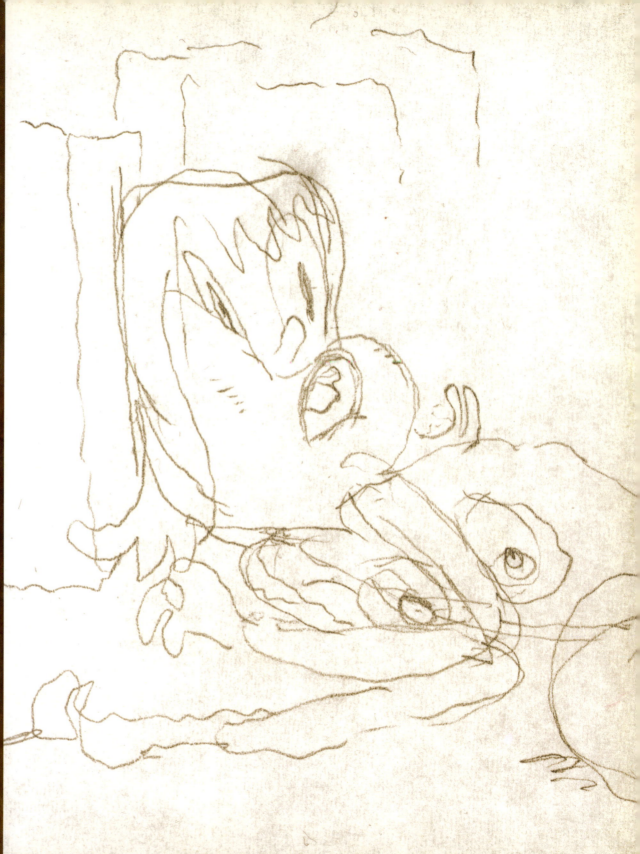

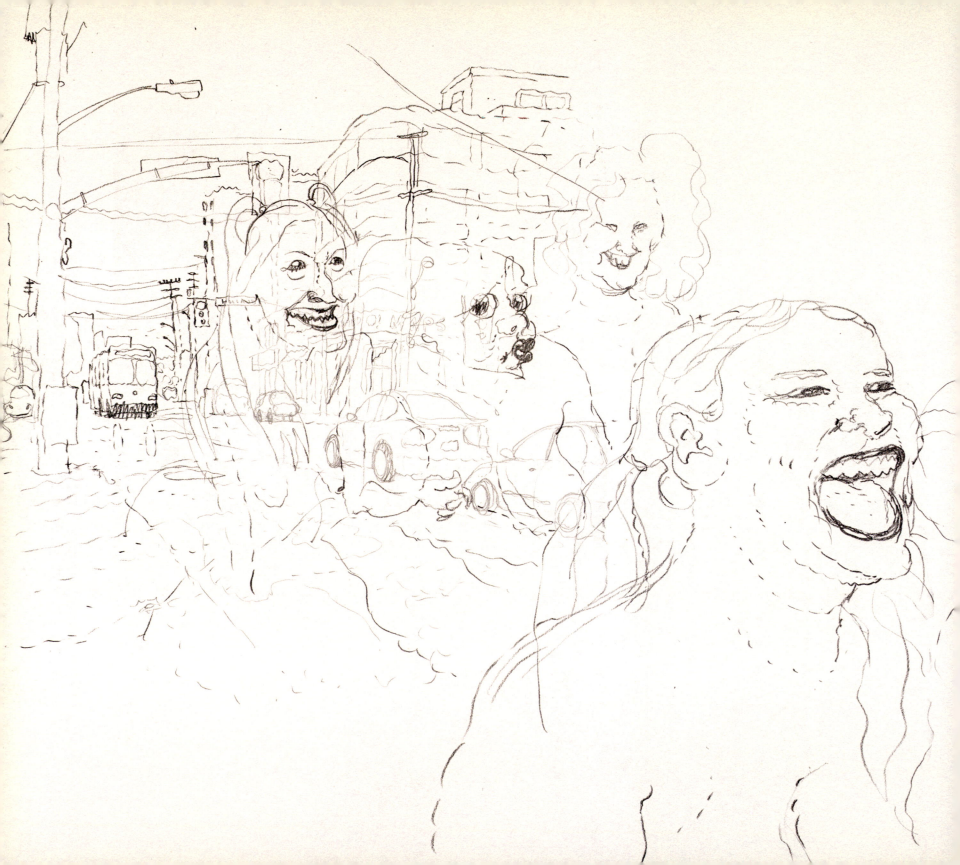

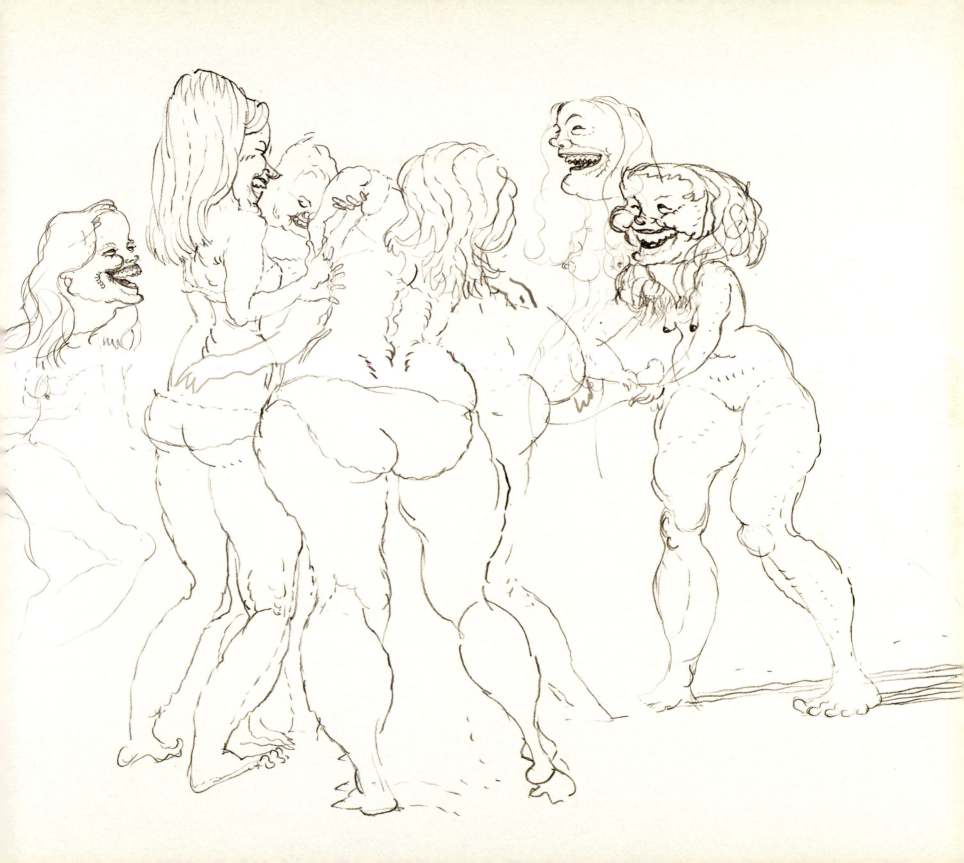

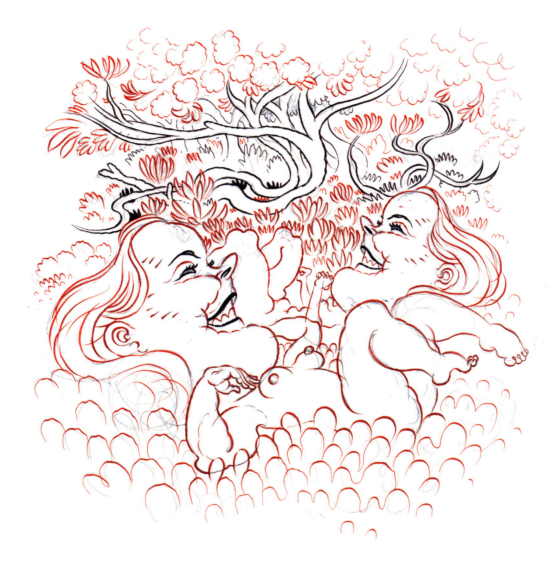

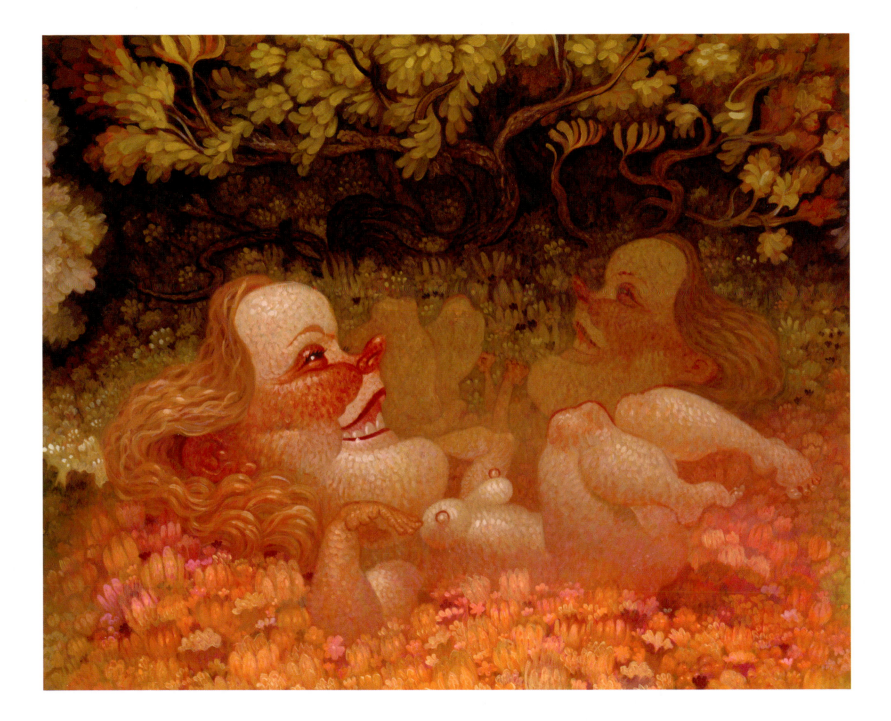

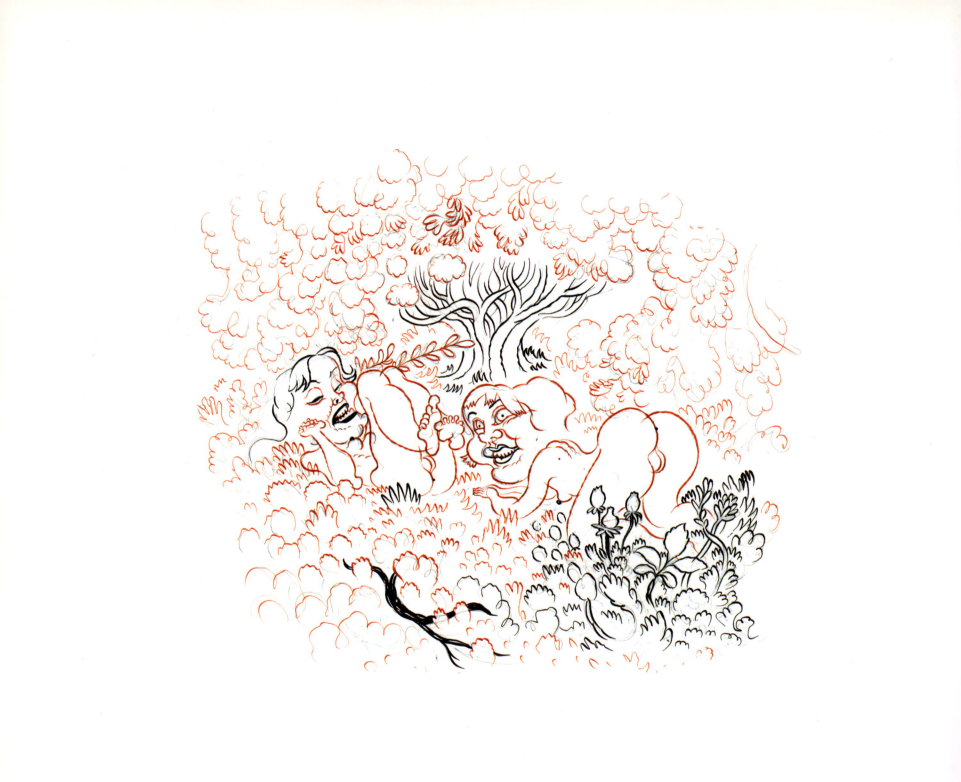

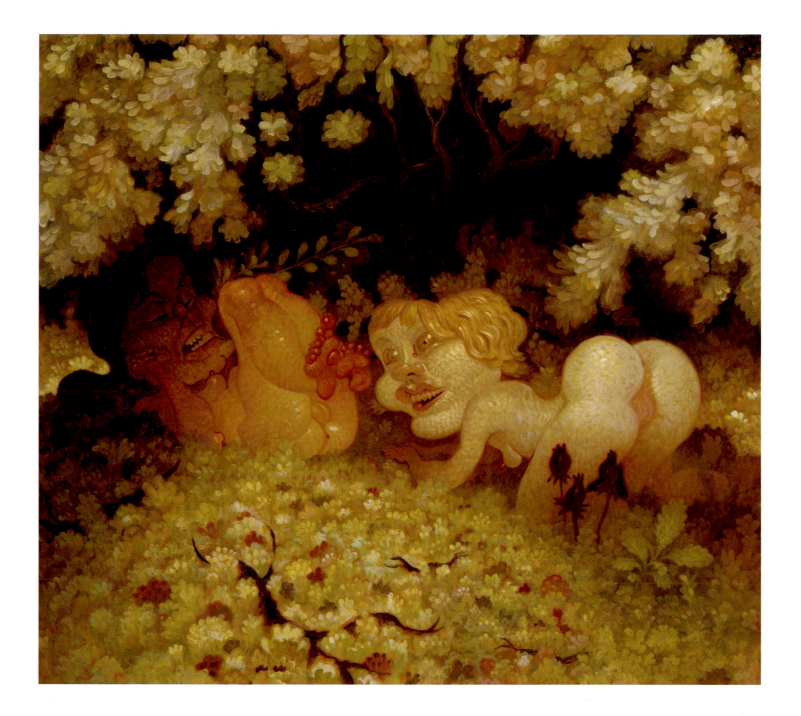

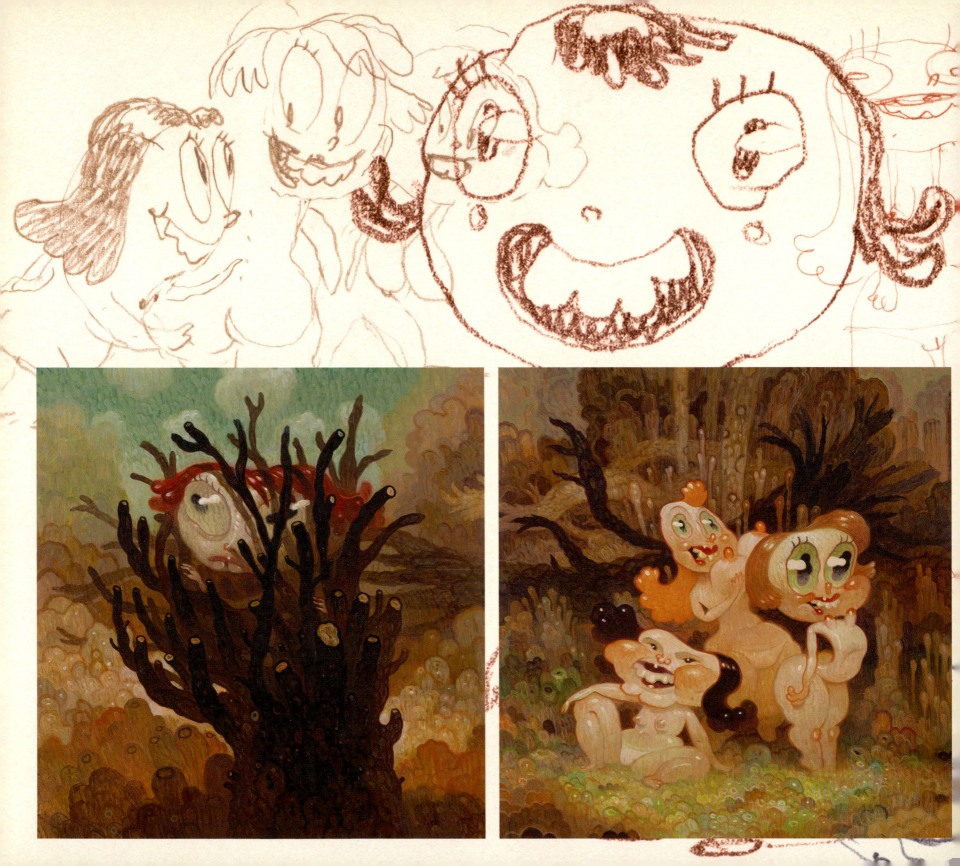

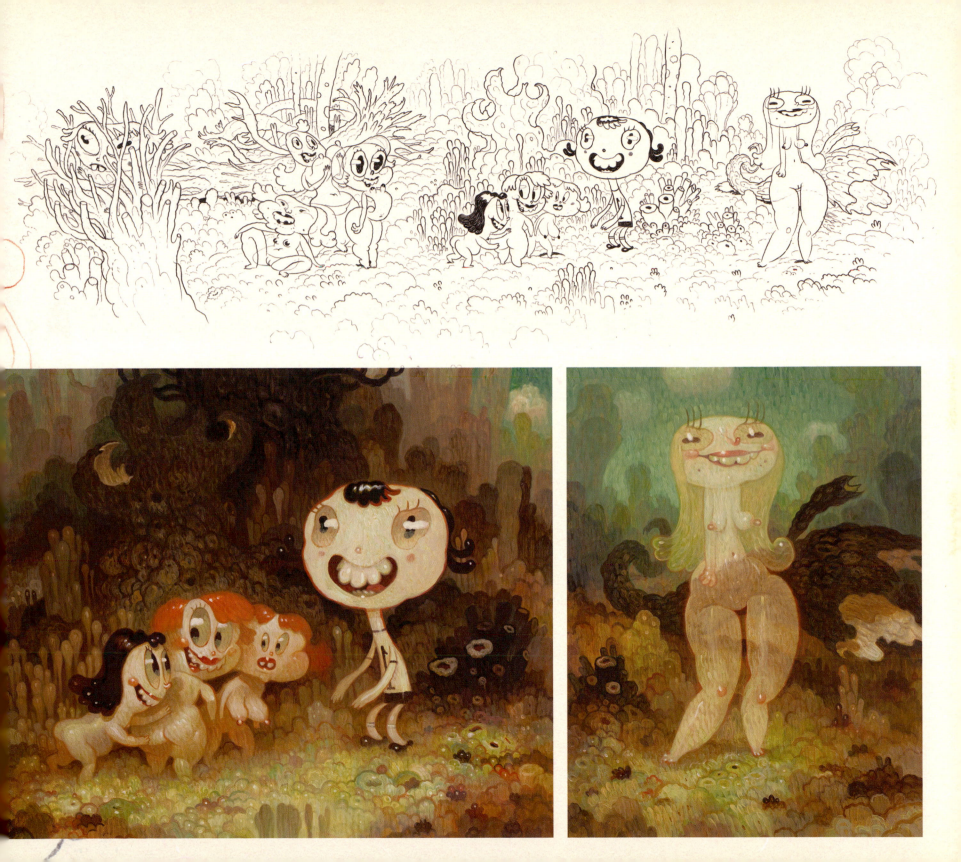

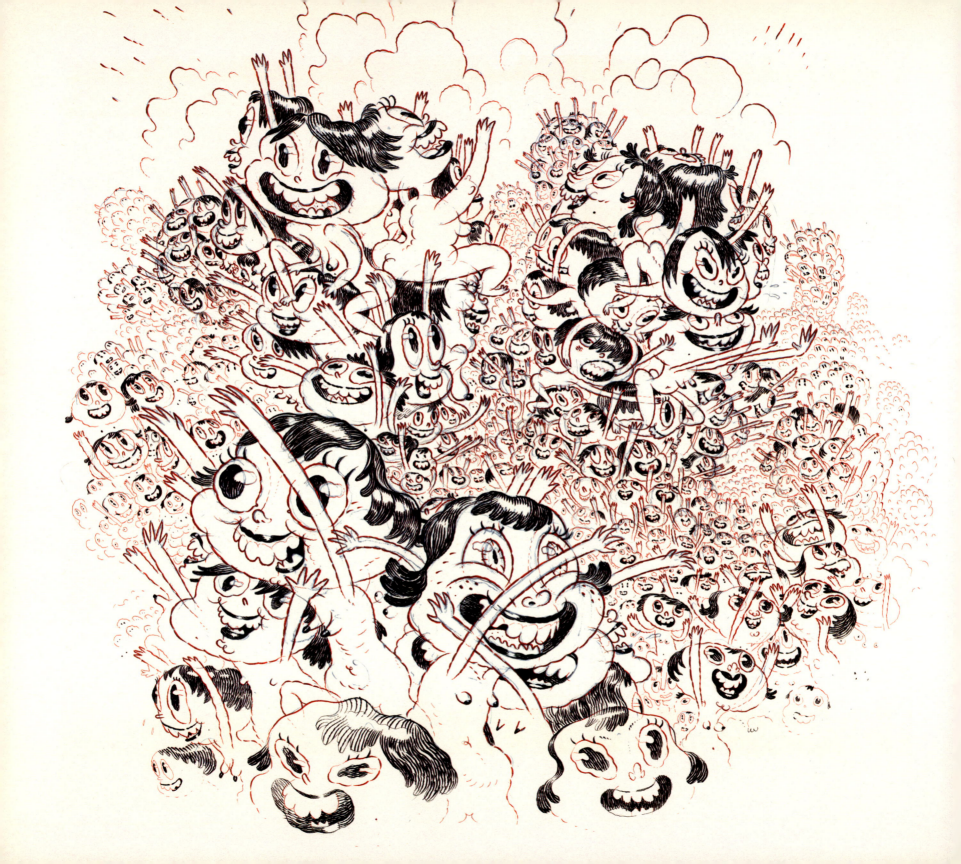

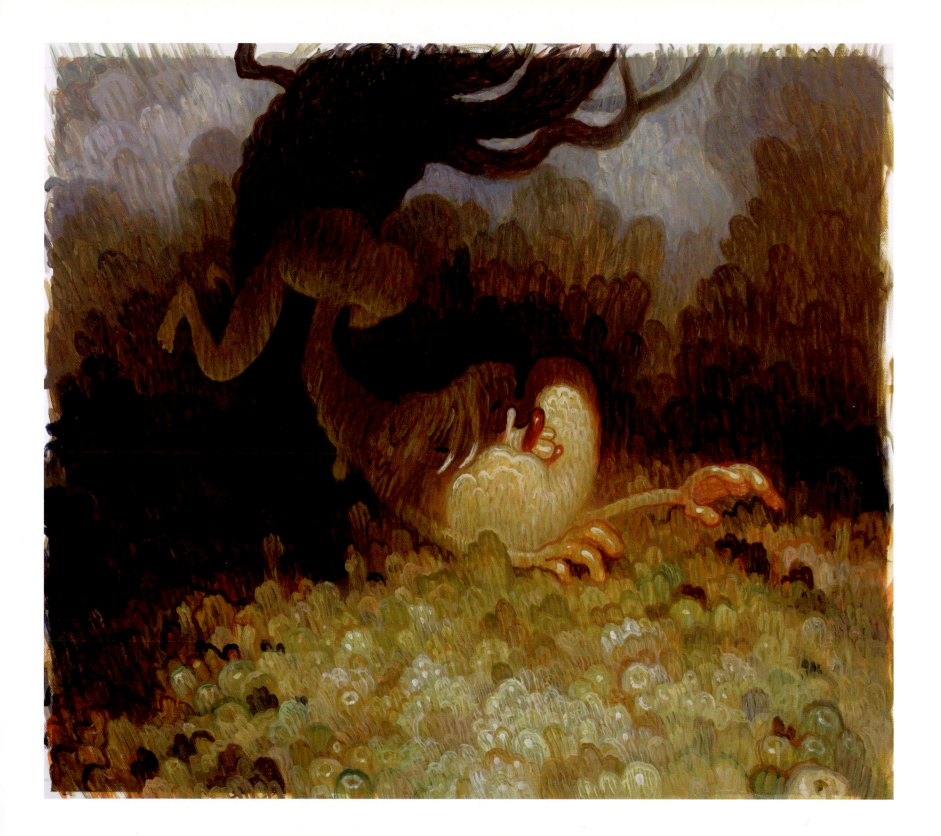

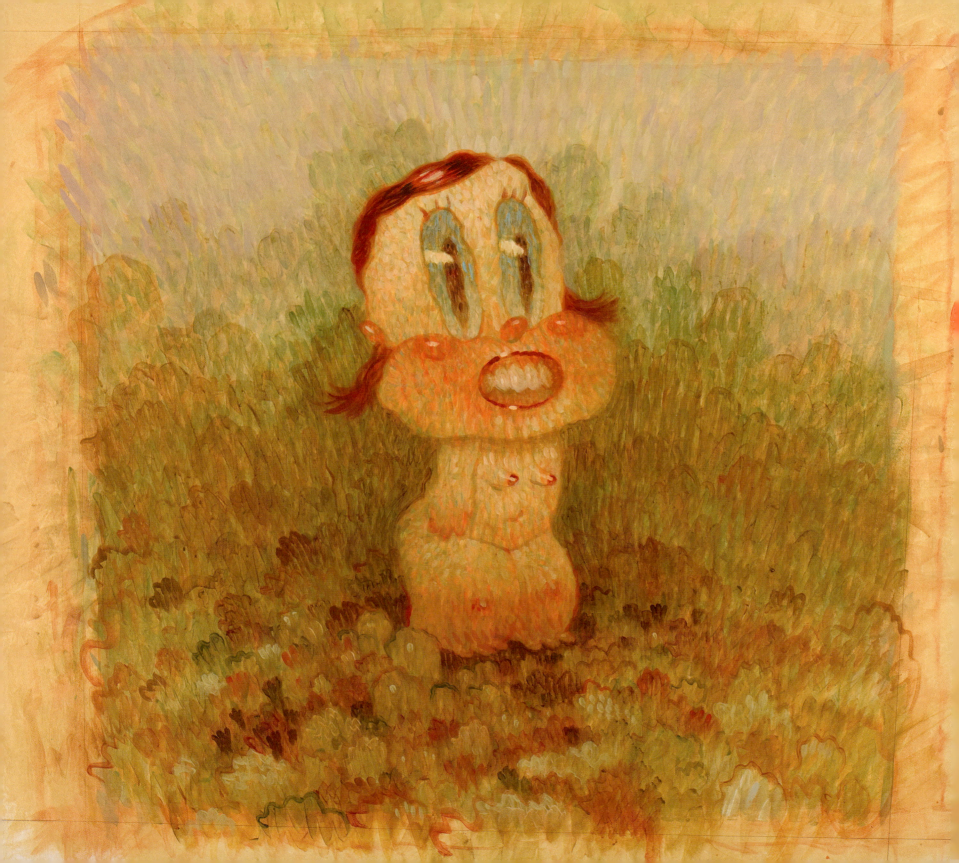

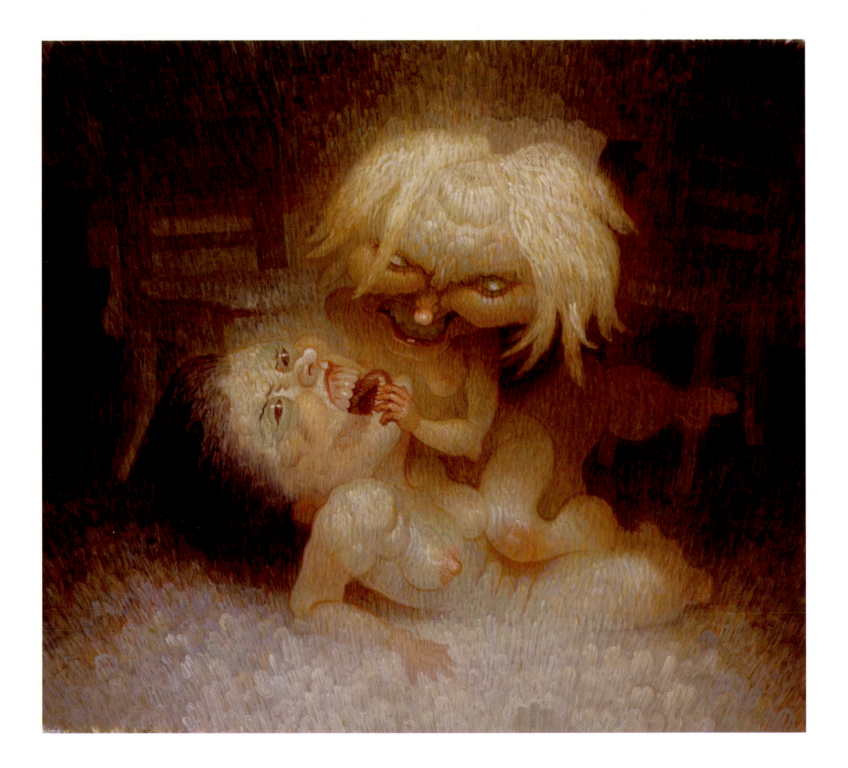

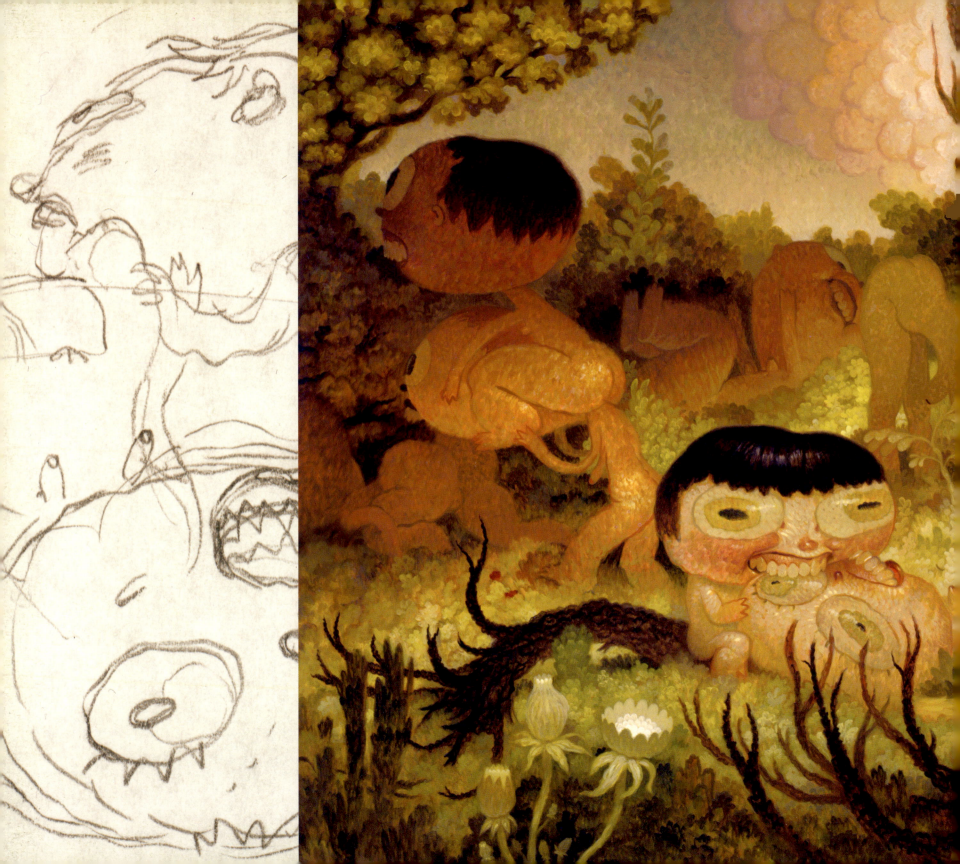

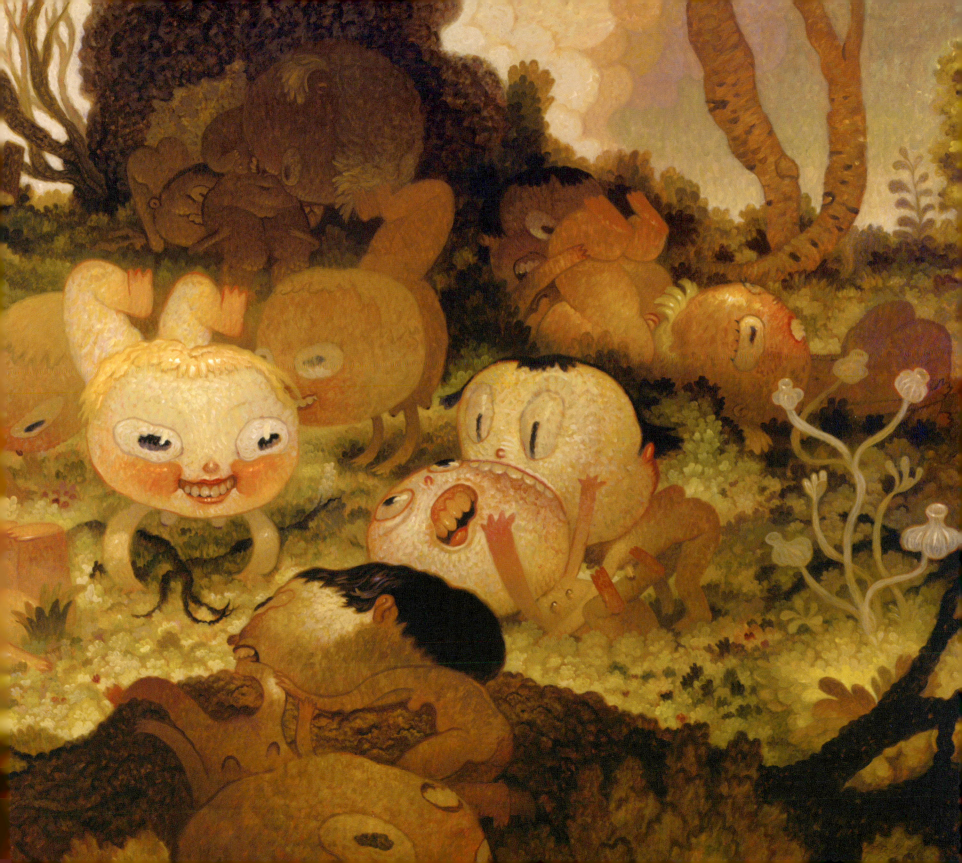

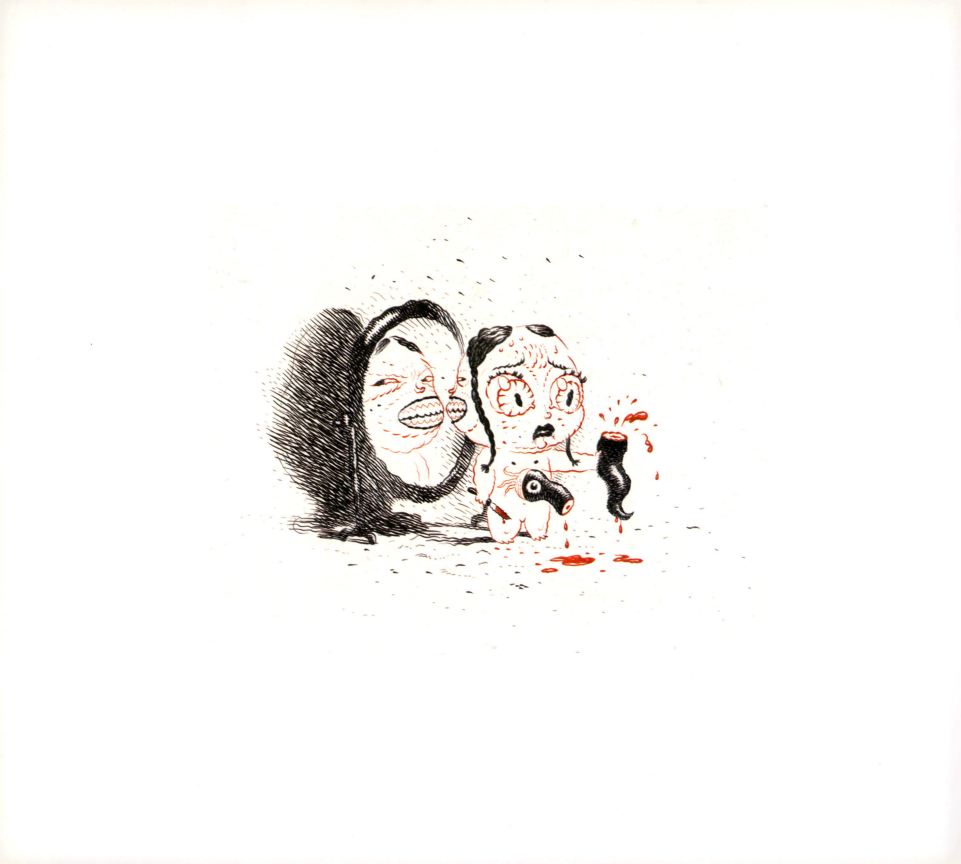

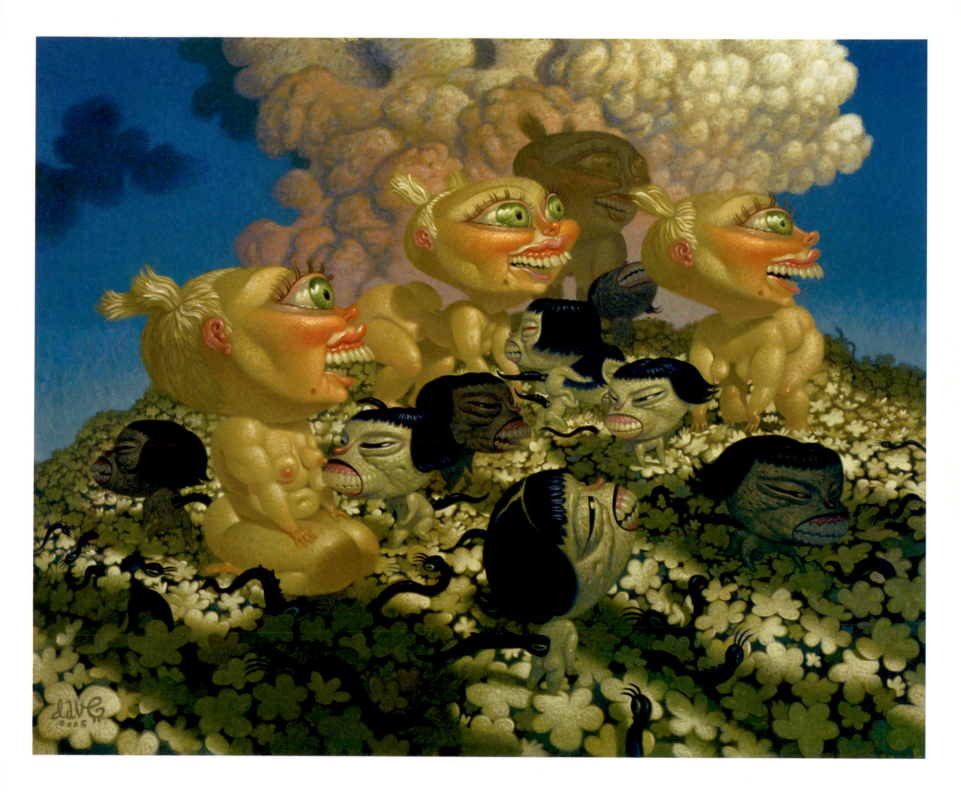

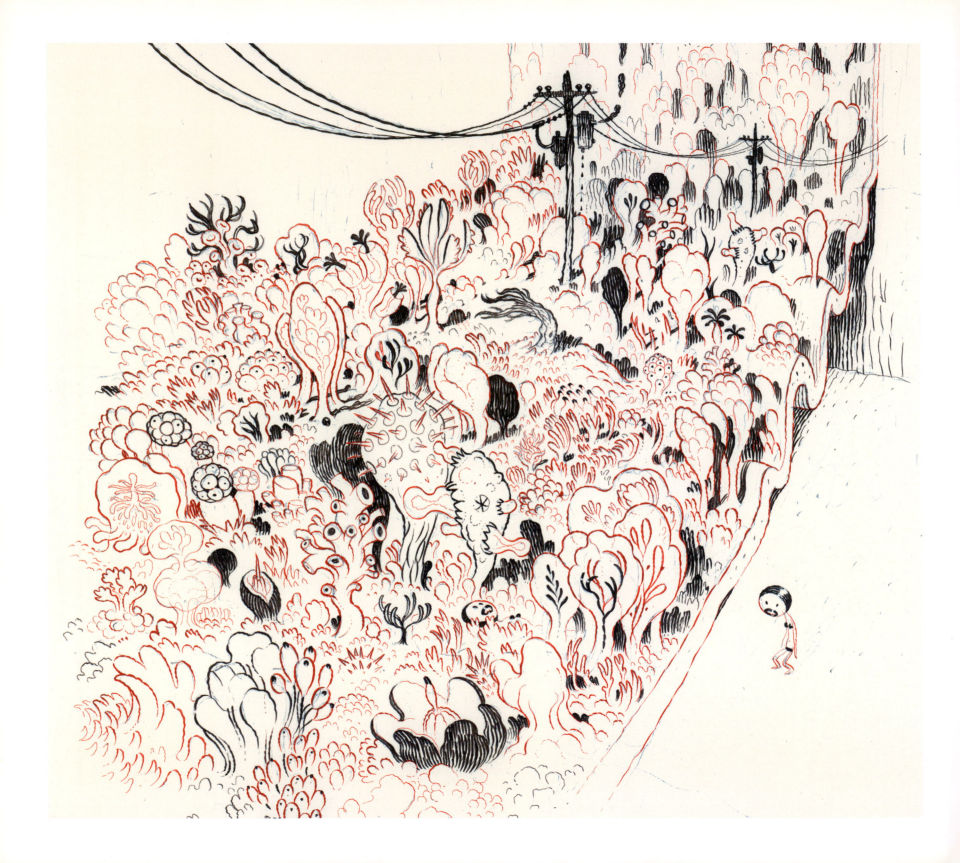

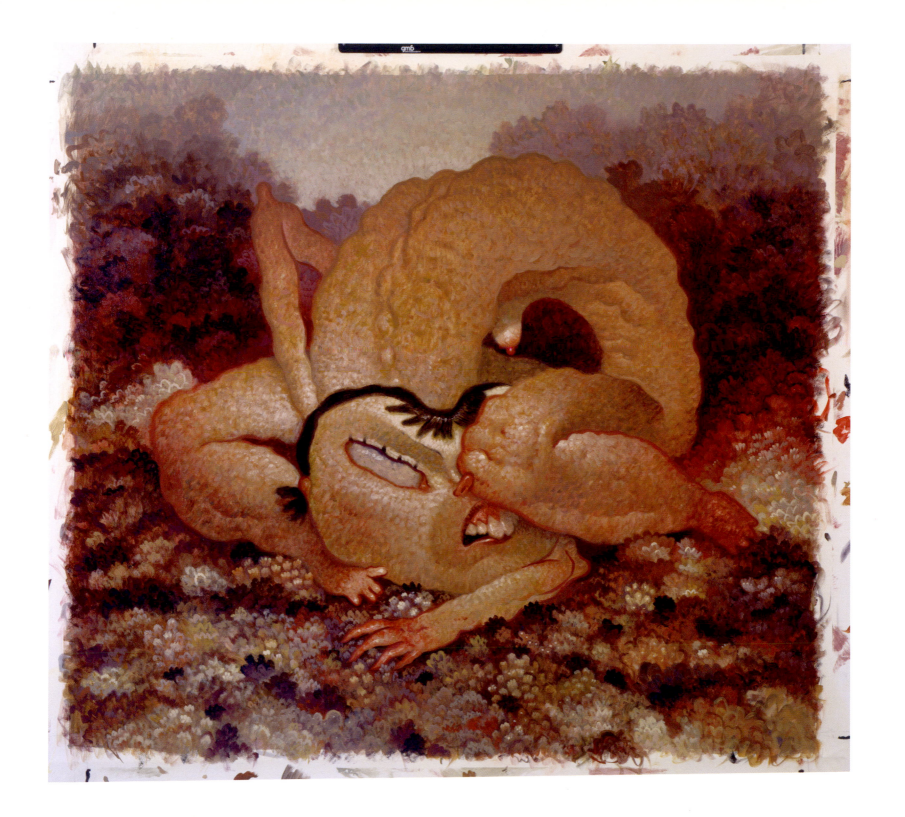

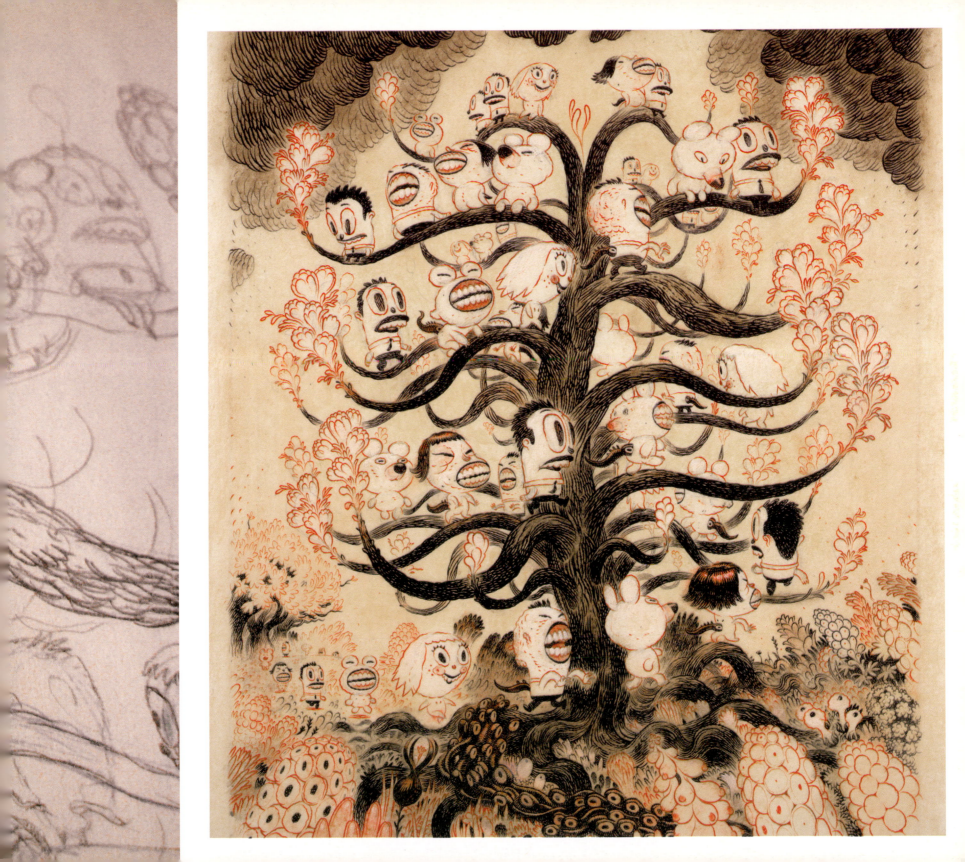

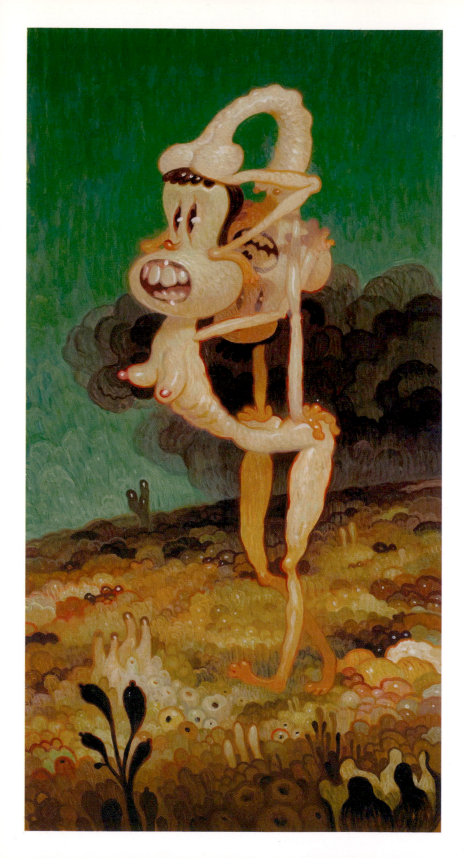
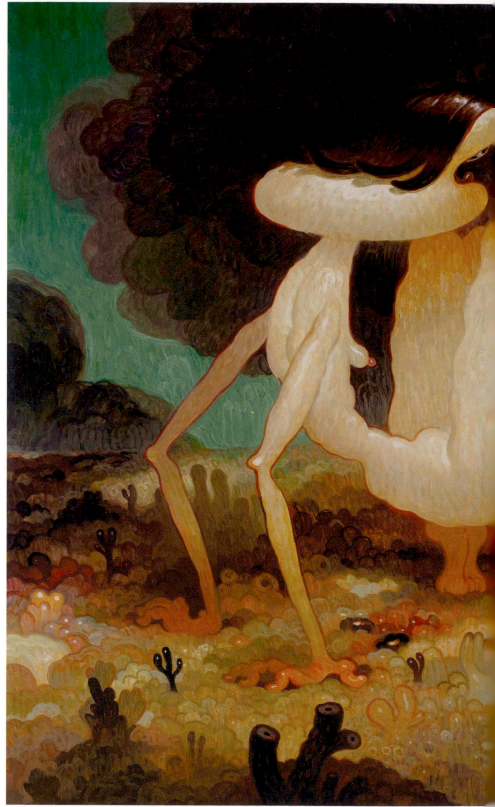

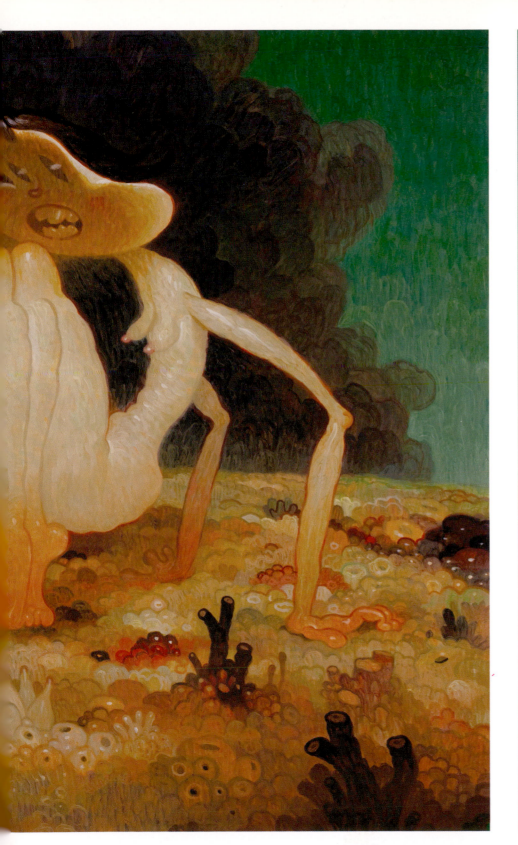
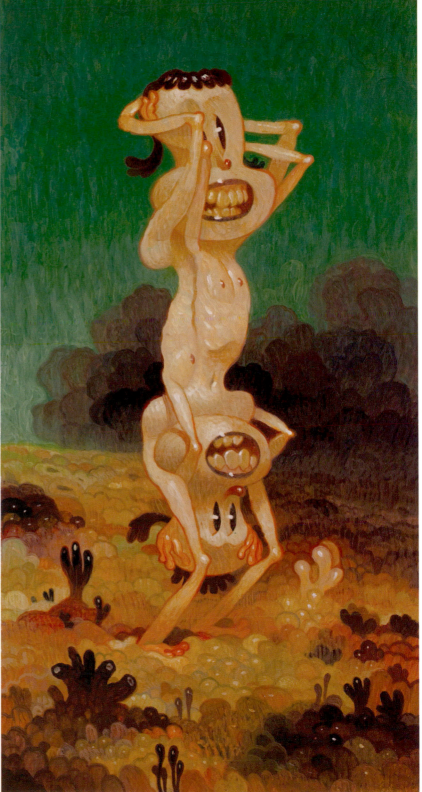

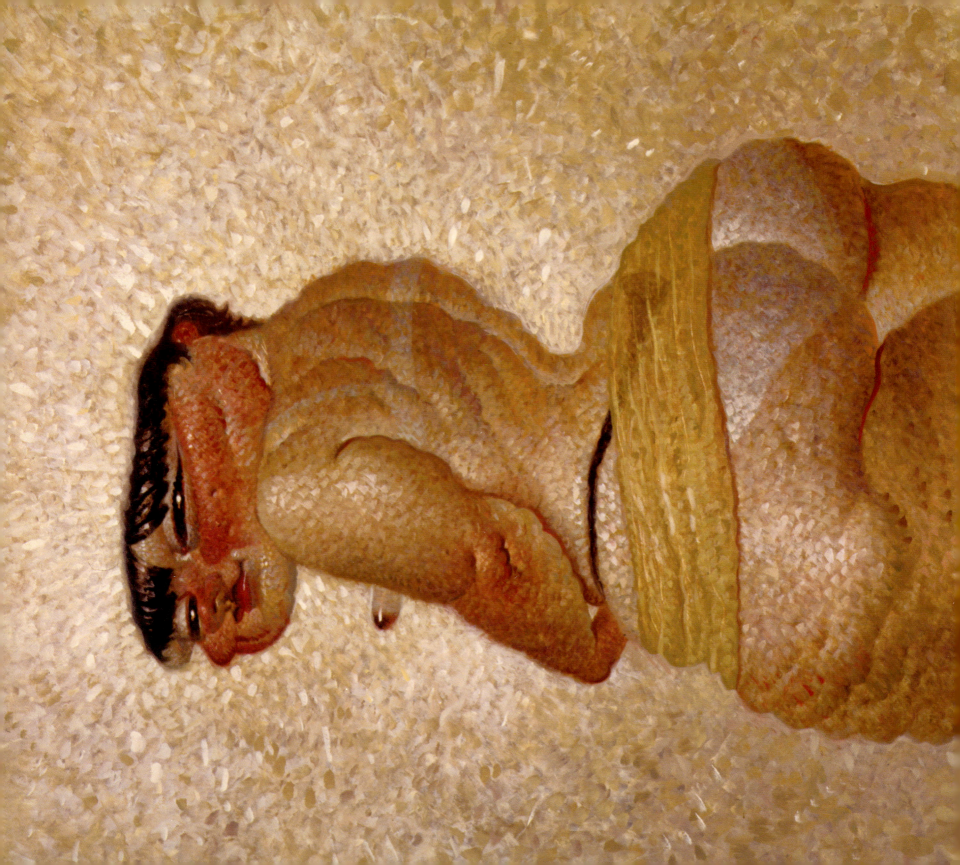

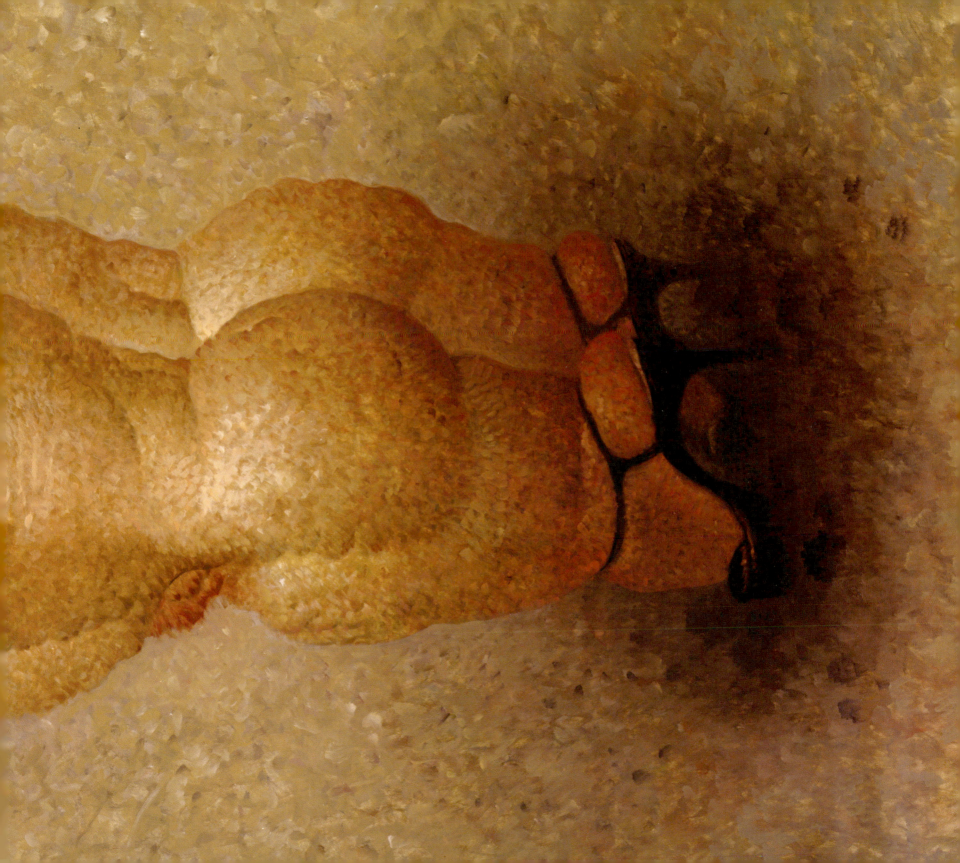

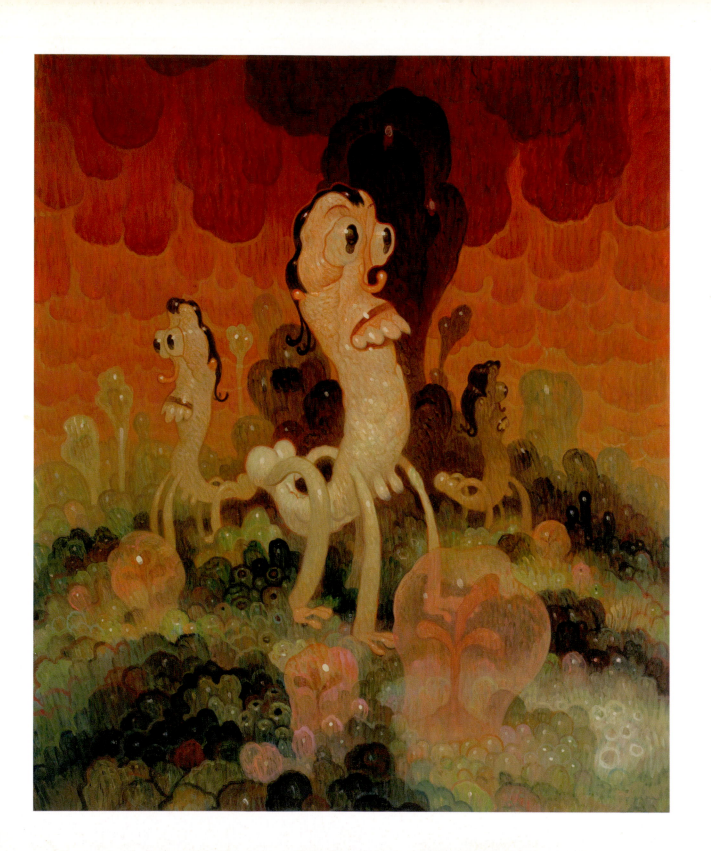

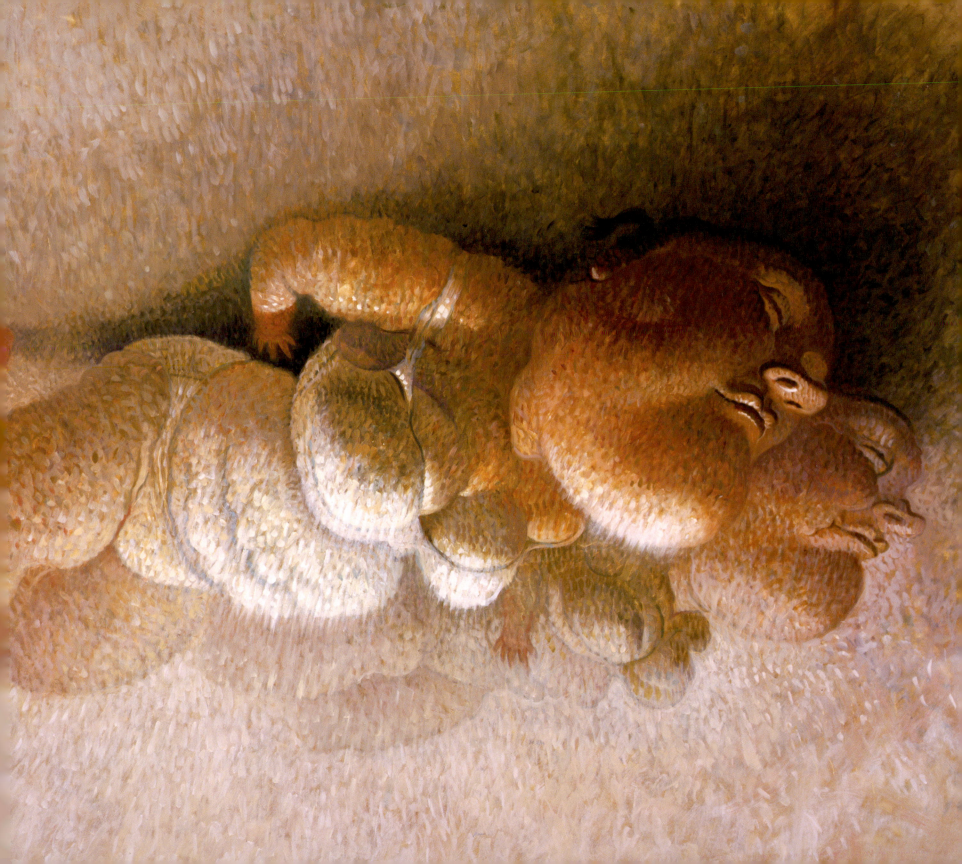

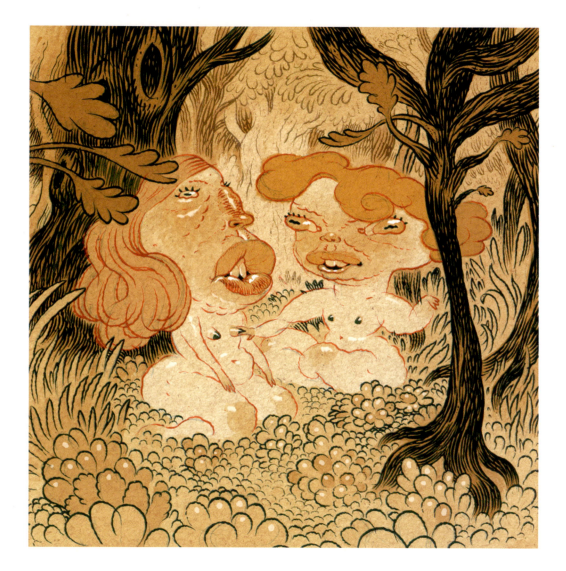

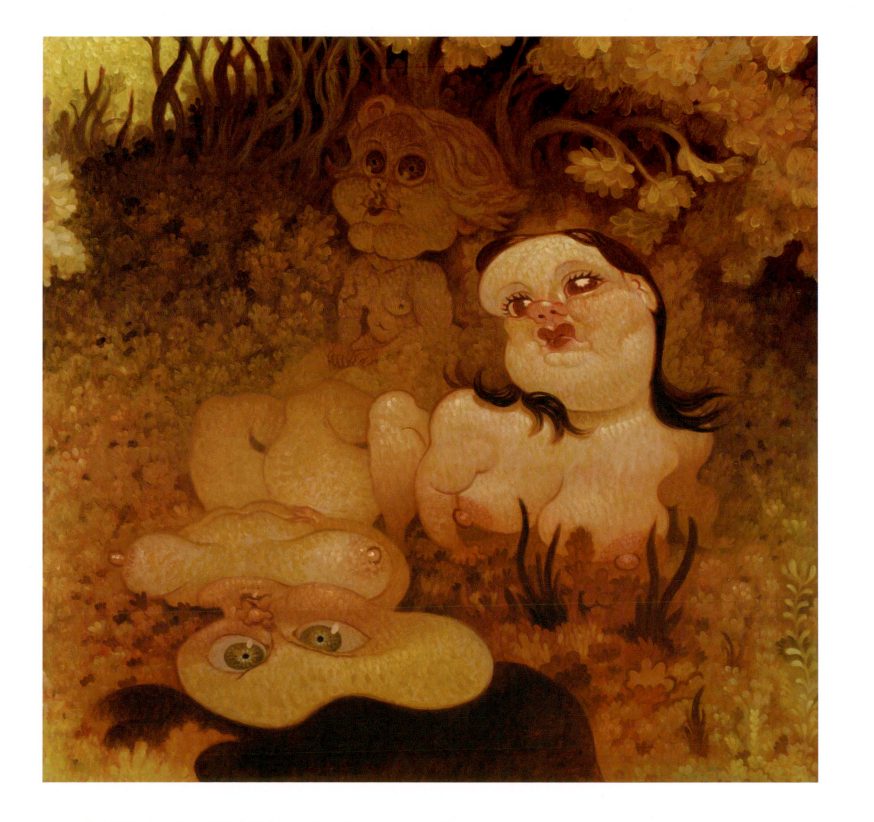

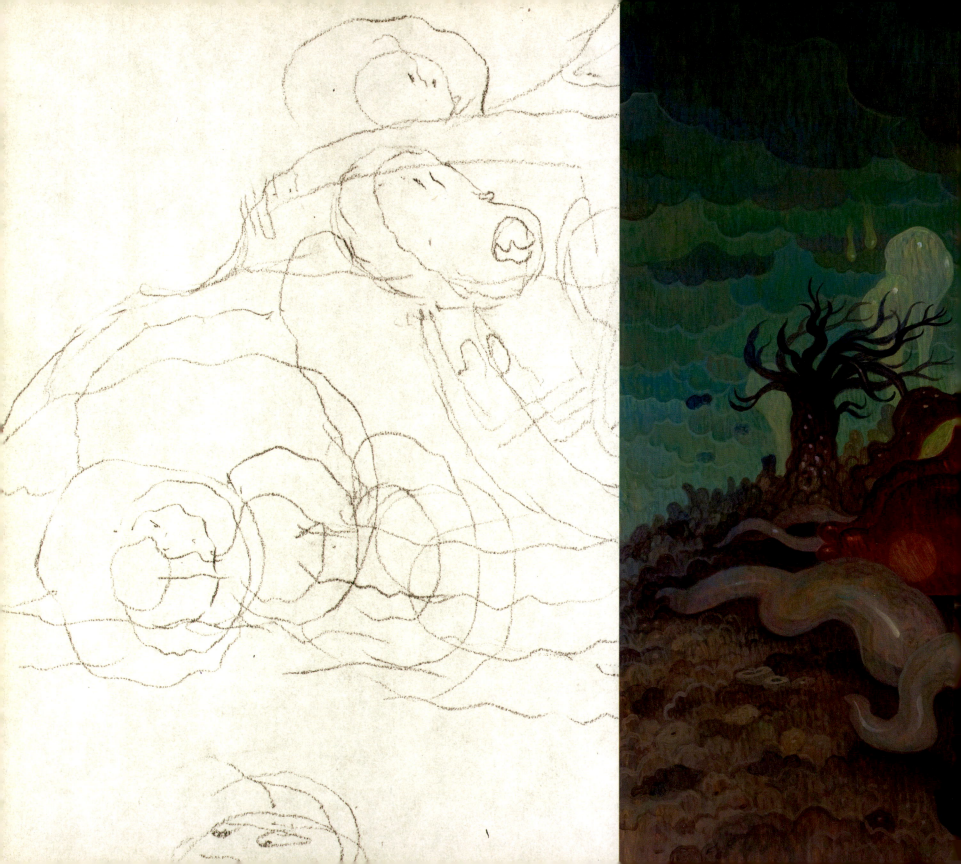

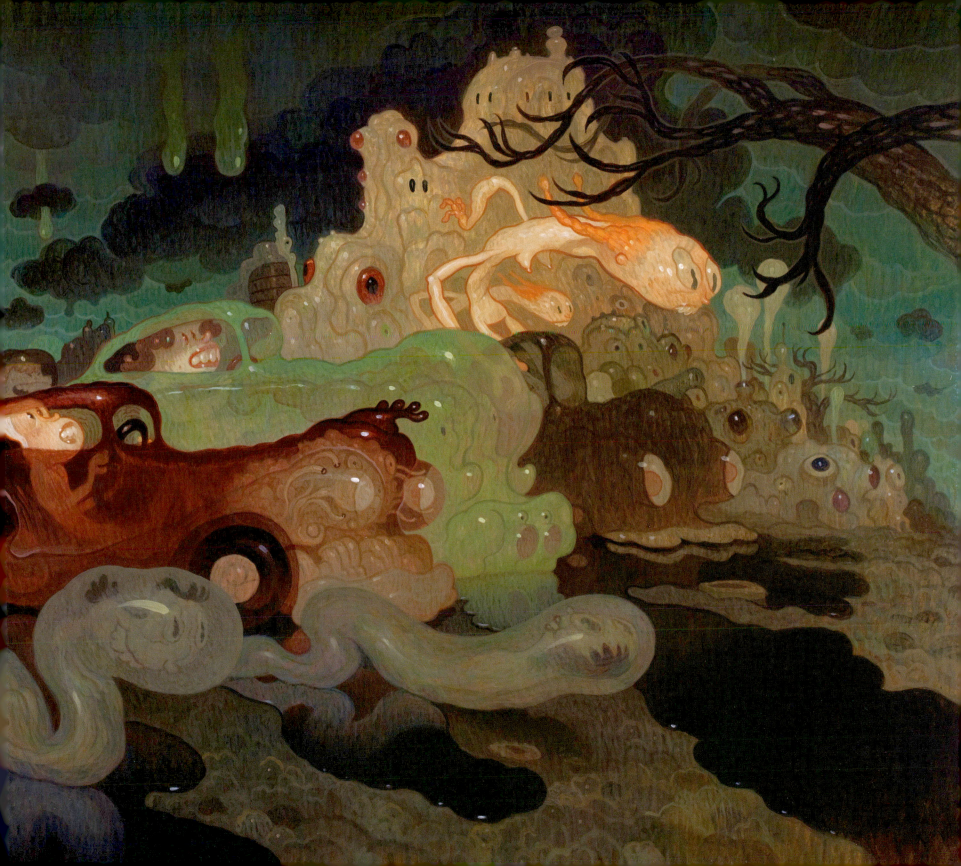

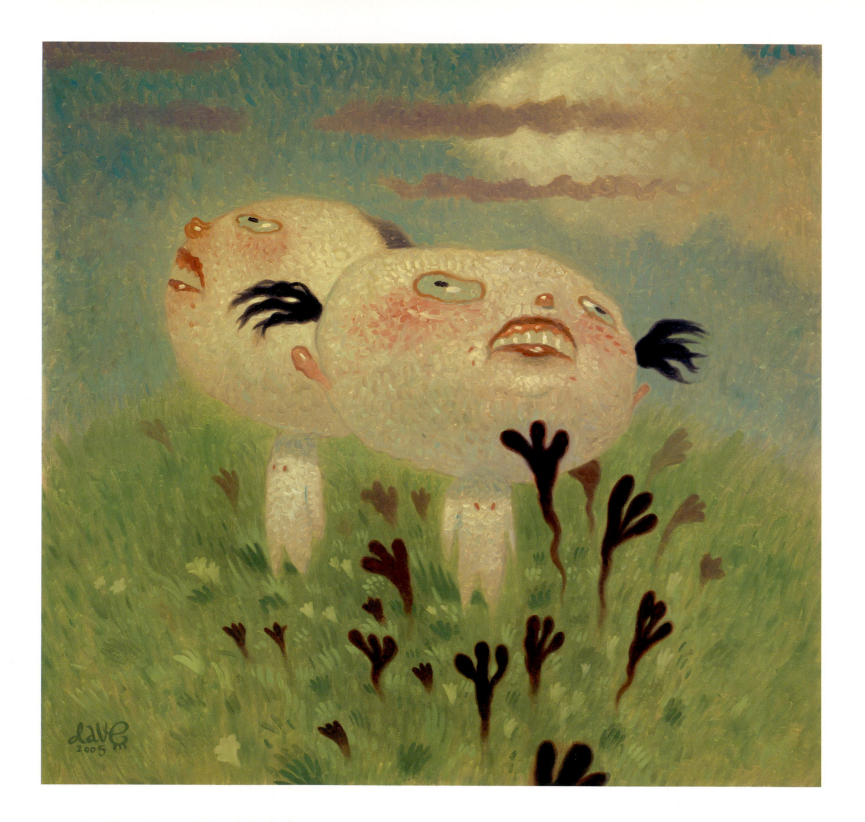

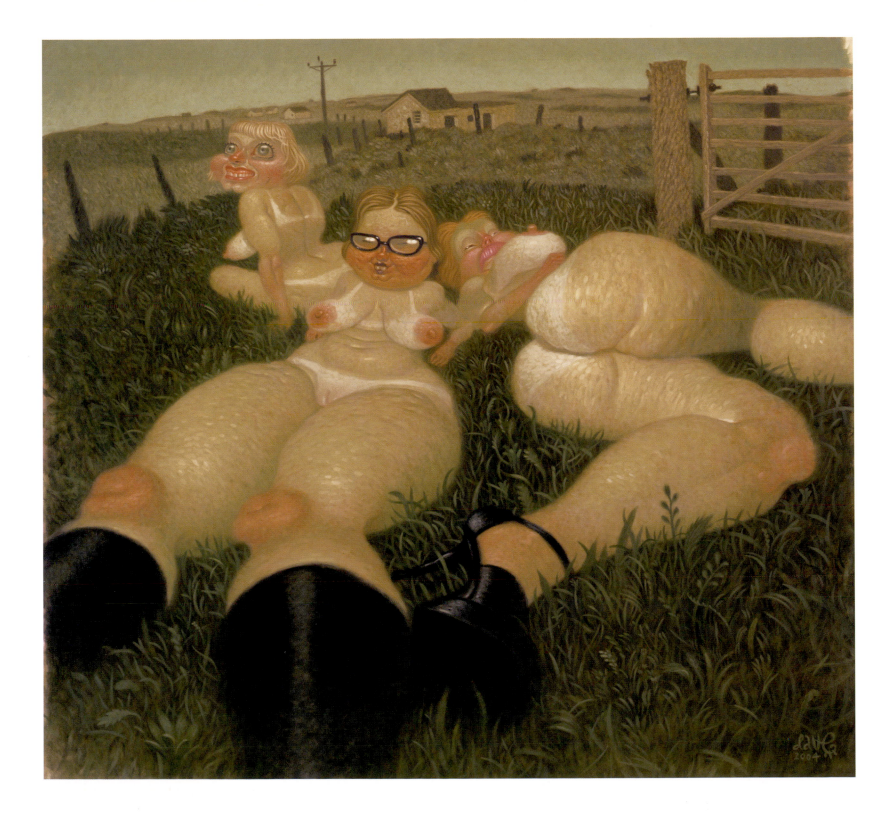

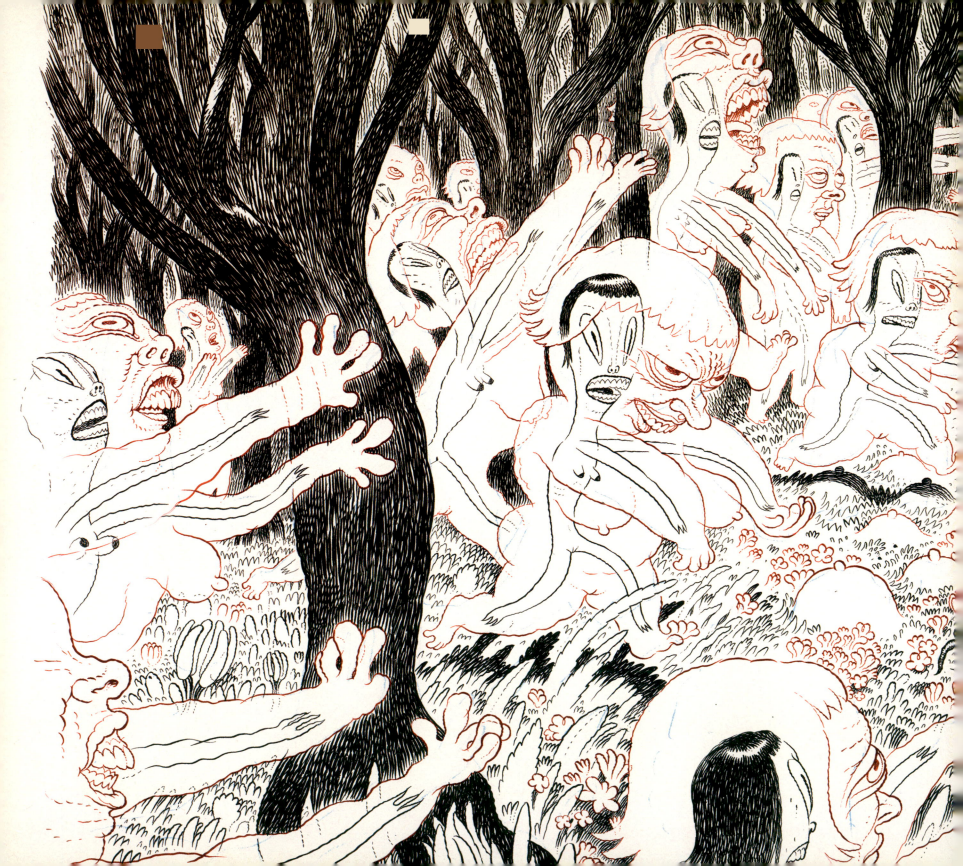

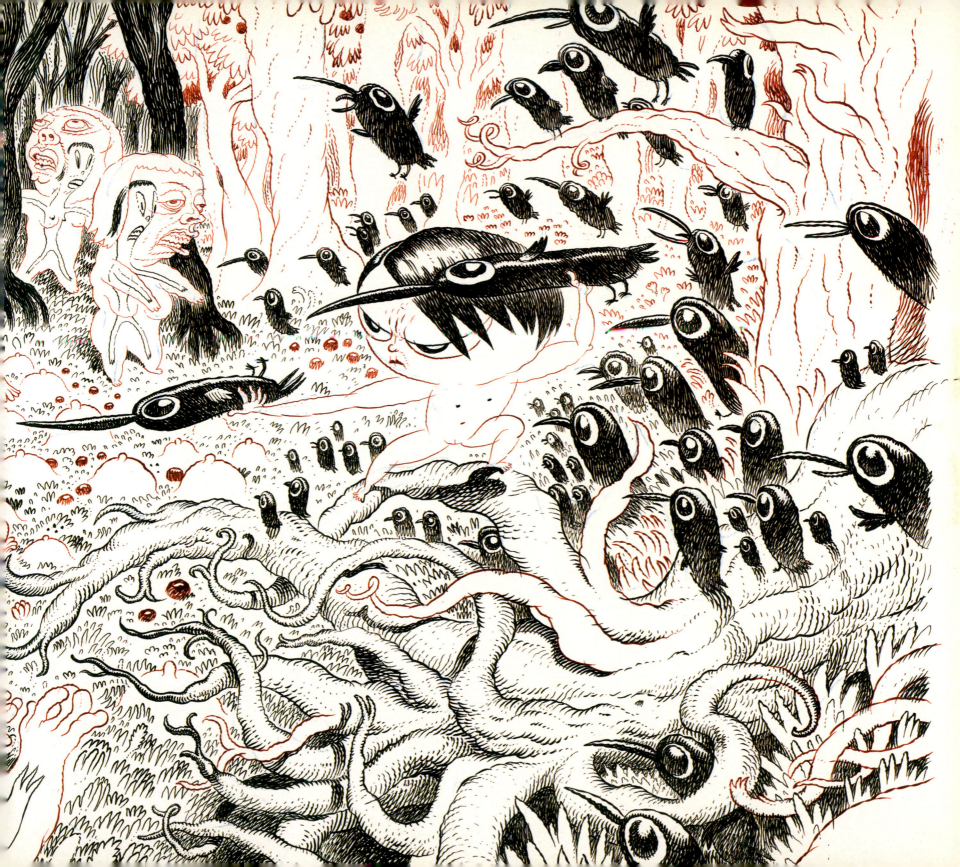

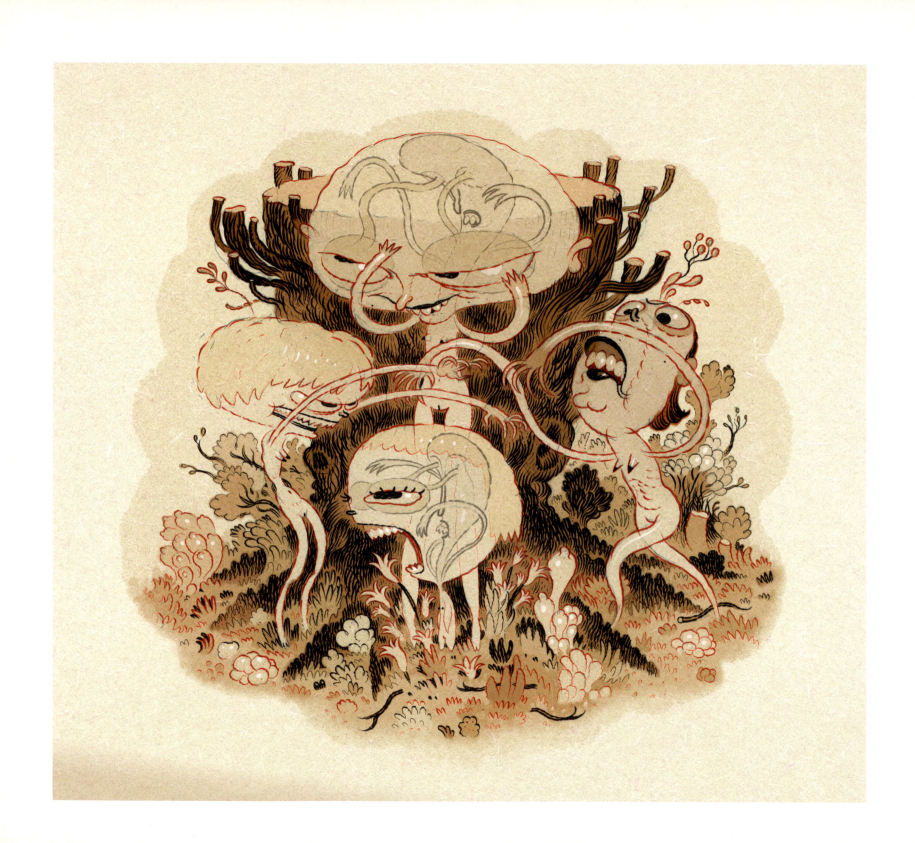

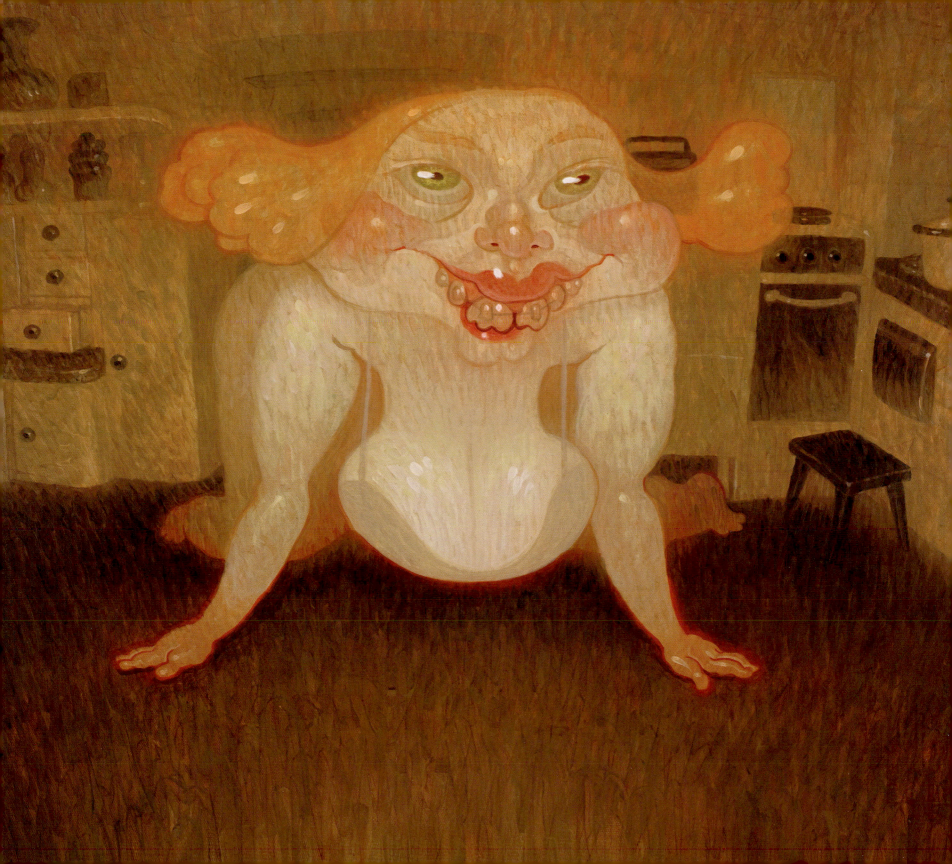

thanks to

Vincent Nguyen

Billy Shire

Alexander MacDonald

Gene Kogan

Jonathan LeVine
Evan Piricco
Troy Nixey
Andrea Poncia
Sell
Bob
Pam Meldrum

Scott Eder
Guillermo del toro
NATHAN SPOOR

Patrick McCoun
Vincent Bernière
Jason Vaughan
Brandon McVittie
Adam Jones

Yves LaRoche et Ximena
Fred Blanchard
JACOB COVEY
DANKO JONES
Barry Yates

Morgan Spurlock
Dave Andrews
Julie+Brian
Emilie Compheone

Marc Plouffe
John+Nichole
Jan+Bruce Helford
Jeanette Moreno

Nick Cross
Gavin McInnes
John Calebrese

Linda Pine
John+Leigh Fenton
Christina Anastassopoulos
Gerben Schermer

Bridget+Bill
JASON GRODE
LEILA YOUNIS
Jonathan Ross
Josh Bates

Louise Goodman
Guy Berube
Wayne Bartlett

Gary, Kim+Eric

contact dave at:
www.
dave
graphics
.com

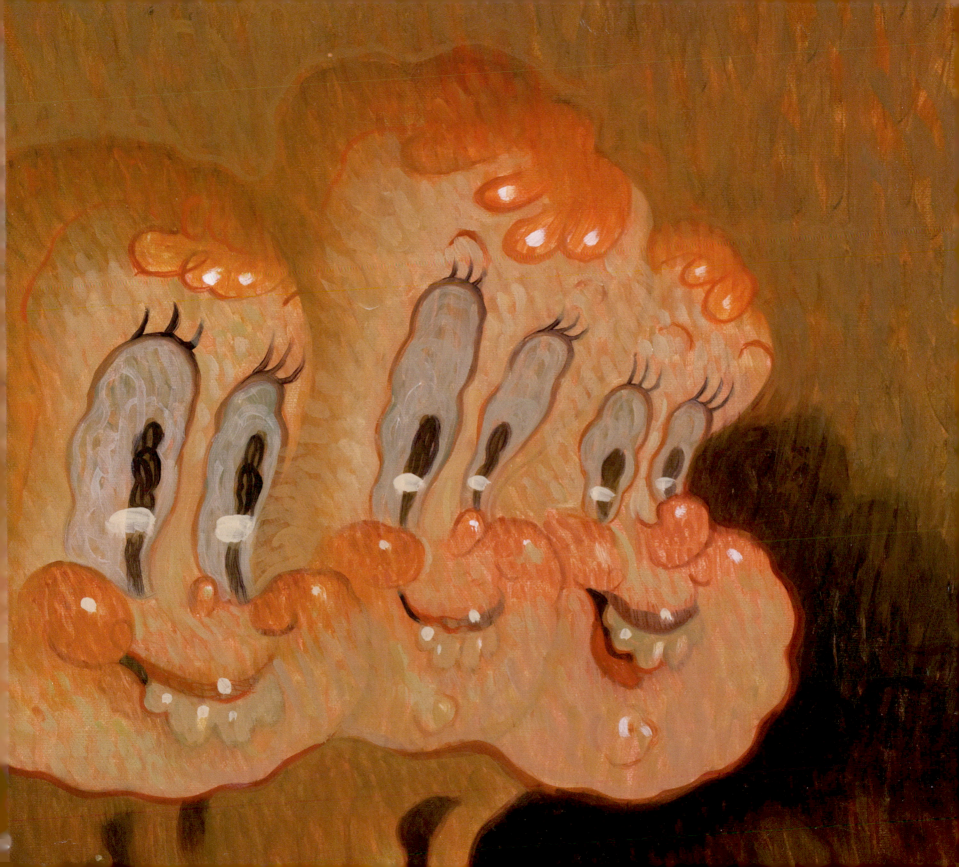

Dave Cooper was born in a Canadian fishing village in 1967.

His parents, Michael and Angela, encouraged his creative impulses from an early age. And as a result, a career in the arts was something that always seemed like a foregone conclusion to Dave. As a child he was inspired by both his father's fascination with machinery and fine industrial design, and his mother's love of nature. Among other early influences were the grotesque, ever-present BMJs *(British Medical Journals)*, and unwitting exposure to the brilliant, sometimes perverse work of the great Tomi Ungerer *(who happened to be a family friend)*.

From his early teens to his early 20s, Dave mentored under the late alternative comics entrepeneur, Barry Blair. This early immersion ultimately lead to a successful career in the American underground comix scene of the late '90s. Seattle's *Fantagraphics Books* published Dave's acclaimed works *Ripple*, *Dan & Larry*, and *Weasel*, among others. Around this time Dave began branching out into the fields of designer toys, animation, and *(under the pseudonym Hector Mumbly)* children's books.

In his 30s Dave focused his energies on oil painting. Since 2003 he's had multiple solo gallery shows in Los Angeles, New York City, and Paris.

Dave lives in Canada with his lovely wife and their two beautiful children.